limited
budget

First published in the United States of America by:
Rockport Publishers, Inc.
33 Commercial Street
Gloucester, Massachusetts 01930-5089
Telephone: (978) 282-9590
Facsimile: (978) 283-2742

Distributed to the book trade and art trade in the United States by:
North Light Books, an imprint of
F & W Publications
1507 Dana Avenue
Cincinnati, Ohio 45207
Telephone: (800) 289-0963

Other Distribution by:
Rockport Publishers, Inc.
Gloucester, Massachusetts 01930-5089

ISBN 1-56496-515-5

10 9 8 7 6 5 4 3 2 1

Designer: Monty Lewis

Printed in Hong Kong.

graphicidea

gíR

resource

limited
budget

Building Great Designs
on a Limited Budget

Lesa Sawahata

ROCKPORT
PUBLISHERS

Rockport Publishers, Inc.
Gloucester, Massachusetts

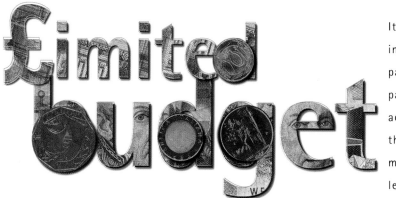

£imited budget

It's an old but true cliché that necessity is the mother of invention. A corollary might be that a low budget is the parent of innovative design for, as reflected in these pages, it seems that great design is not only accomplished despite budgetary restraints, but because of them. Fortunately for graphic designers, it is often their most creative clients who have small budgets and will leap for intrepid, innovative, and inexpensive design.

The most popular means for avoiding the high-priced invitation, annual report, promotional piece, and identity packet? Restricting the use of color. Simple, two-color print jobs, especially with standardized PMS colors, keep printing costs down. Even more amazing are one-color jobs: not just black-and-white, (though black-and-white designs can be lovely), but a single color of ink printed on different-colored papers chosen for letterhead, envelopes, and business cards, for example, can create impact without expense.

Technology has gone far in enabling designers to create compelling work on a budget. In the past decade, sophisticated and easy-to-use software has brought the creation, manipulation, and production of type and images into the hands of small design firms. Color copiers and laser printers allow for small runs of vibrant color pieces, while copyright-free photography and clip art available on disk offer endless possibilities for customizing content.

Along with this tsunami of technology has come an equally strong emphasis on design by hand. When a minor amount of product is needed, (wedding invitations for example) hand-assembly (including cutting, trimming, folding, stamping, cutting, binding, and silk-screening) can bring inordinate charm to a piece.

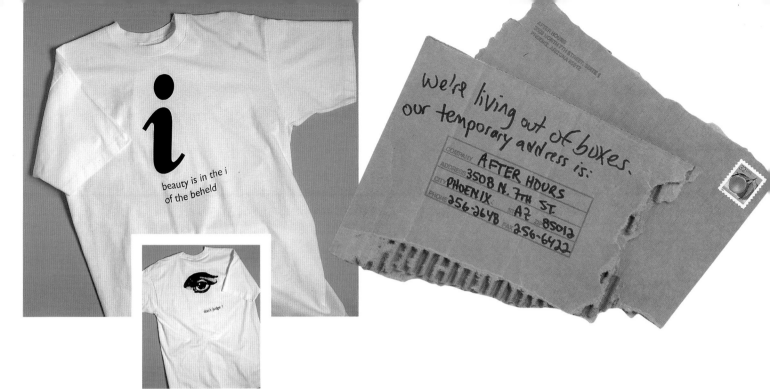

And let us not forget two excellent cost-cutting methods: begging and scavenging. If a designer has a relationship with a printer or paper manufacturer, often enough a surplus of unused stock, a new and untried paper style, or sheer generosity, will provide the client with paper at almost no cost. And of course, minimizing the number of processes used in printing (sticking to very simple folding, die cutting, etc.) will reduce the amount spent.

This volume is filled with innovative, cost-cutting concepts that show terrific design can be the result of a small budget and big ideas.

To create his own letterhead, the designer manipulated images using Adobe Photoshop, Painter, and Adobe Illustrator. The bold, vintage-urban look was achieved by printing in two colors on toned recycled stock.

Larry Burke-Weiner Design letterhead/business card

Metal Studio, Inc. labels

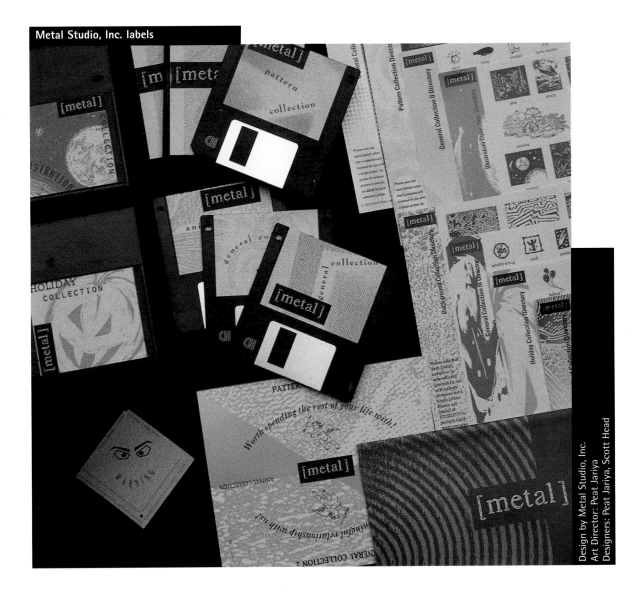

Design by Metal Studio, Inc.
Art Director: Peat Jariya
Designers: Peat Jariya, Scott Head

This design firm needed a low-cost, versatile means
to label its digital design disks. By using Adobe
Illustrator and PageMaker, printing in two colors, and
making the labels interchangeable between lines,
they met their goals.

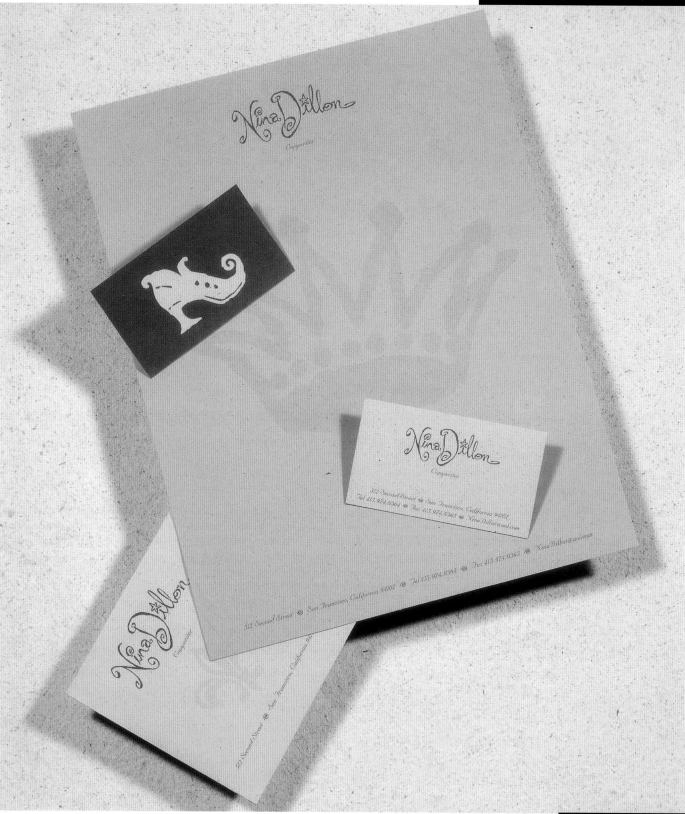

All Design: Tim Noonan

Choosing various colors of stock for letterhead, business cards, and envelopes, and printing the whimsical illustrations and type in one PMS color kept costs low on this charming identity packet.

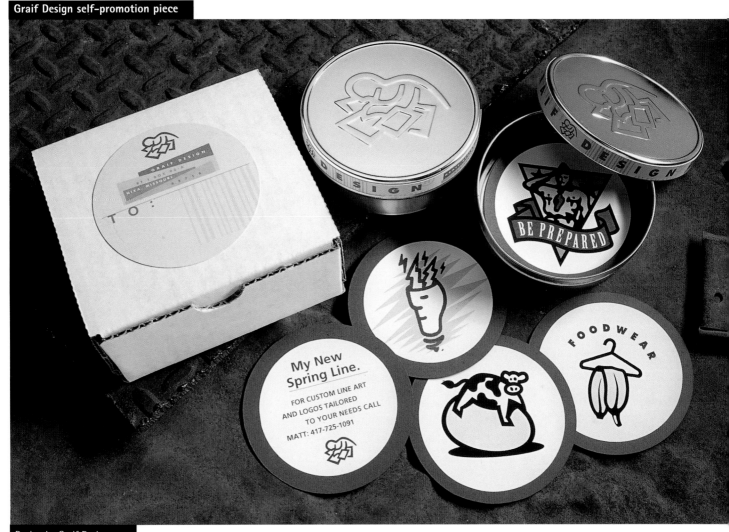

Graif Design self-promotion piece

Design by Graif Design
All Design: Matt Graif

In discovering these cans—which he subsequently had printed and embossed—this designer found the perfect venue for presenting his new spring line. The result was maximum impact for a mere five dollars a piece.

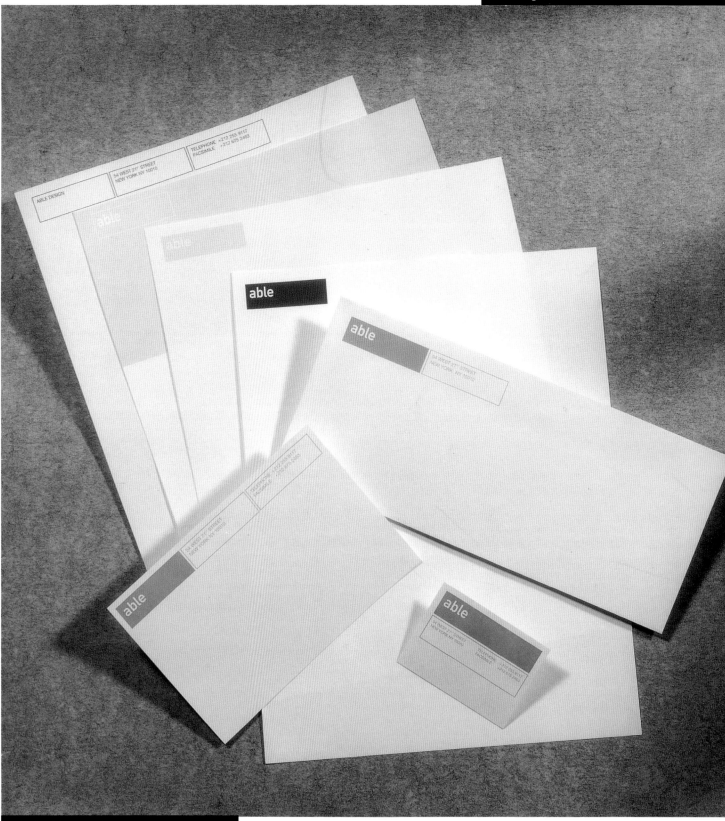

Design by Able Design, Inc.
Art Directors: Stuart Harvey Lee, Martha Davis
Designer: Martin Perrin

Getting more for the money meant this design firm printed their letterhead four-up to get color on both sides. This simple, strong design was created in-house, which proved to be the economical approach.

This evocative piece was created by scanning spot illustrations into a computer, then manipulating with Macromedia FreeHand. Scrap paper was donated by the printer to help cut the budget.

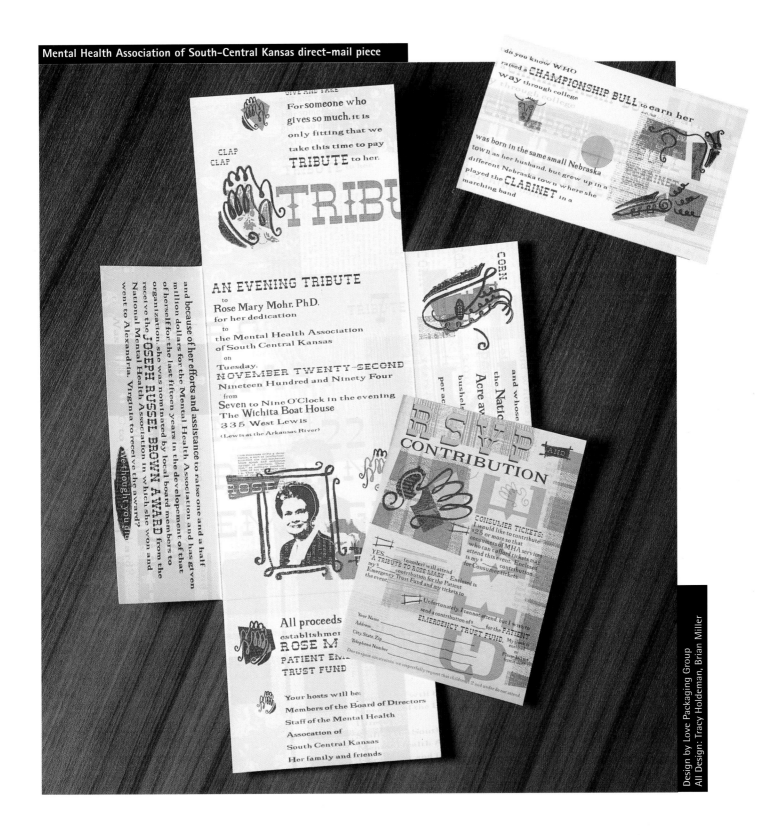

Mental Health Association of South-Central Kansas direct-mail piece

Design by Love Packaging Group
All Design: Tracy Holdeman, Brian Miller

The designer used a Power Macintosh to transform antique botanical illustrations into letterhead for a pair of landscape architects. The Classic Crest paper maximizes the design, printed in one color plus black.

John Howard/Benjamin Roden-Lupton letterhead/business card

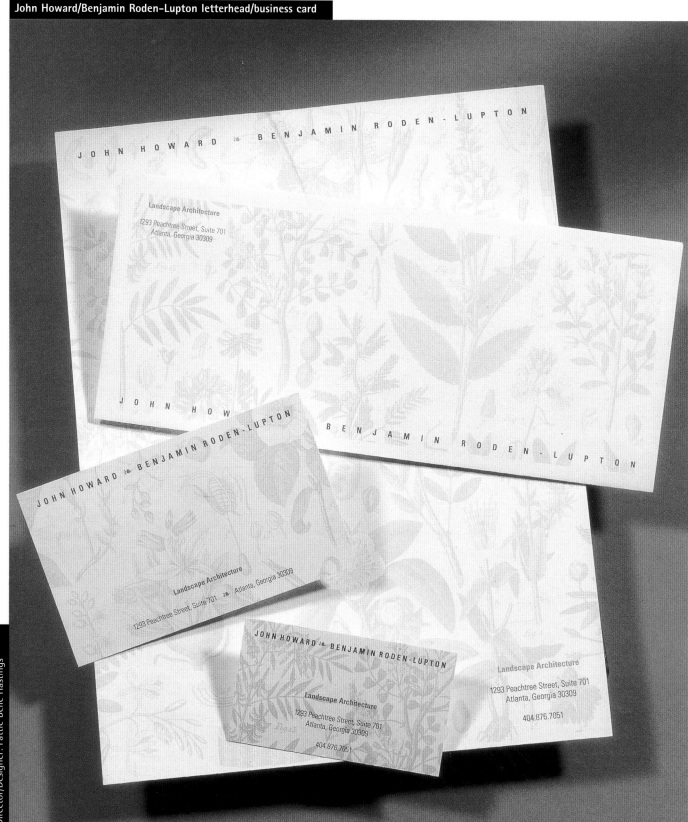

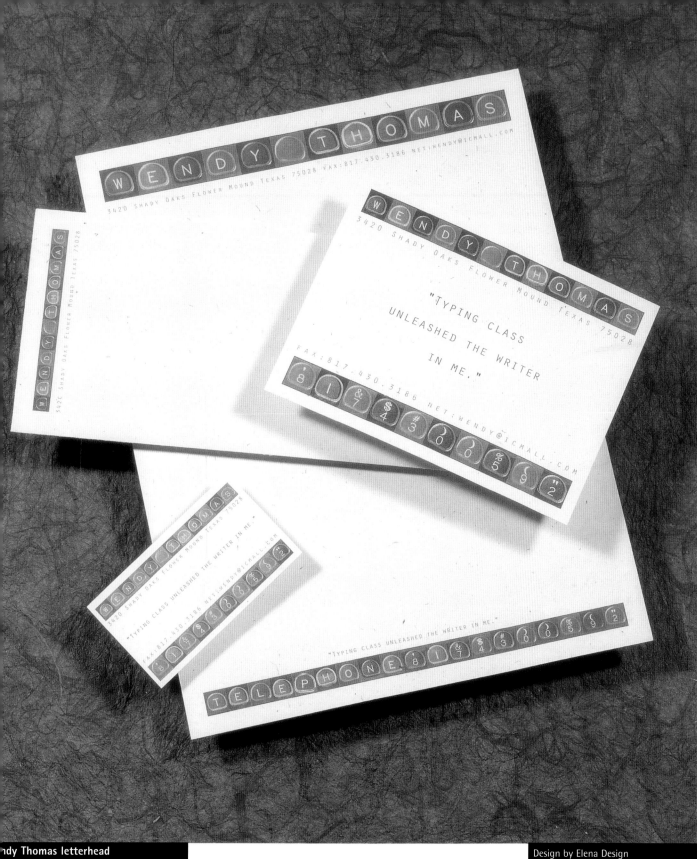

ndy Thomas letterhead

Design by Elena Design
Art Director/Designer: Elena Baca
Illustrator: Phototone Alphabets

To cut costs for this writer's letterhead, the designer used existing art

from a disk and two-color, no-bleed printing. French Speckletone paper

adds interest and disguises any small flaws in the printing.

DO SOMETHING DIFFERENT!

CALL 941-4020 TODAY

get a job and a career

Enroll in Job Link's Learning Center at Roger Williams University • 150 Washington Street, P...

Job Link Employment Services poster

What Do You Want To Be When You Grow Up?

CALL 941-4020 TODAY
And get a real job.

Sponsored by Job Link Learning Center and Roger Williams University Partnership

Design by Manley Design
All Design: Don Manley

This job was a very short run—only a couple of hundred posters were needed. The designer used clip art and his own illustrations, then experimented with a color photocopier, to come up with these potent posters (which cost about sixty cents each).

Alta Clothing Store sale cards

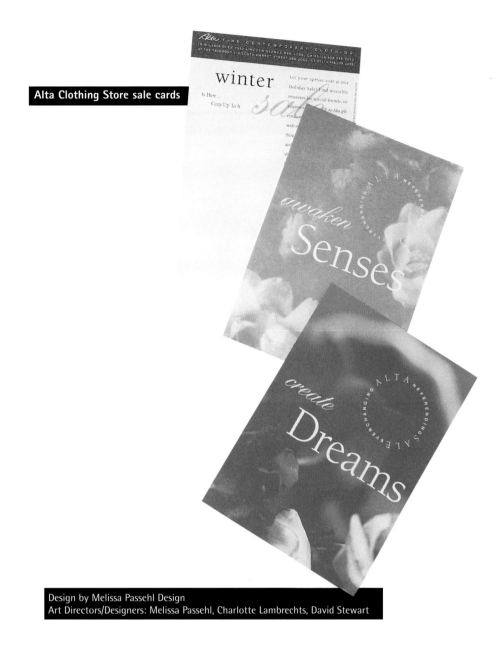

Design by Melissa Passehl Design
Art Directors/Designers: Melissa Passehl, Charlotte Lambrechts, David Stewart

Lyrical and low budget, these seasonal sale cards for a clothing store combine evocative images, poetic text, and unusual colors (two-color process) to make them special.

To cut this budget to the bone, a single, high-quality photograph and stripes of type give visual interest; the cool blue is the single color, paired with black for strength.

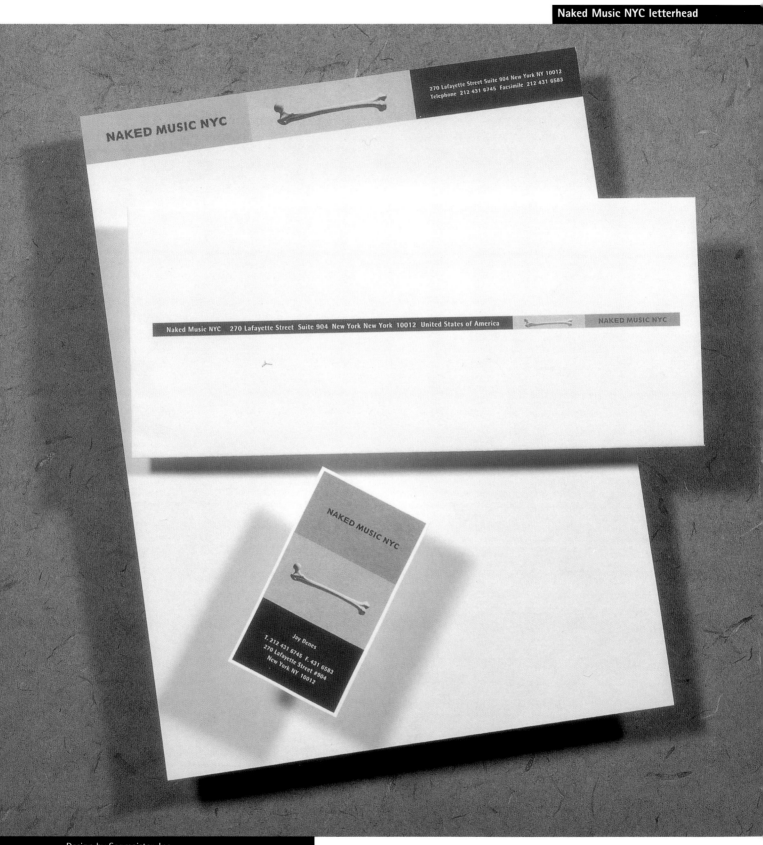

Design by Sagmeister, Inc.
Art Directors/Designers: Stefan Sagmeister, Veronica Oh
Photography: Tom Schierlitz

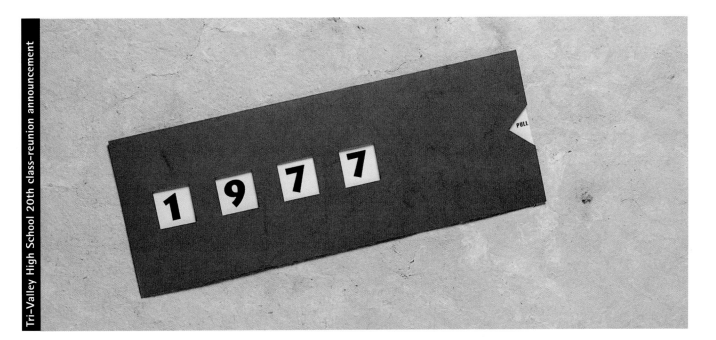

PULL

1 9 7 7

CLASS OF 1977

Please Join Your Classmates from Tri-Valley High School in Celebrating Our 20th Class Reunion.

JIM'S STEAKHOUSE BLOOMINGTON, IL
SAT. JULY 5, 1997 7:00 PM

rsvp by April 15, 1997

PULL

1 9 9 7

Only sixty of these invitations were needed, and the class of '77 had no funds for printing. These pieces were laser-printed, hand cut, and glued. Total cost was twenty-two dollars, plus postage and envelopes.

While the cost of printing is stripped down with the use of a
single color of ink, the designer ingeniously used a color
photocopier to add lively, brilliant color to menus and postcards.

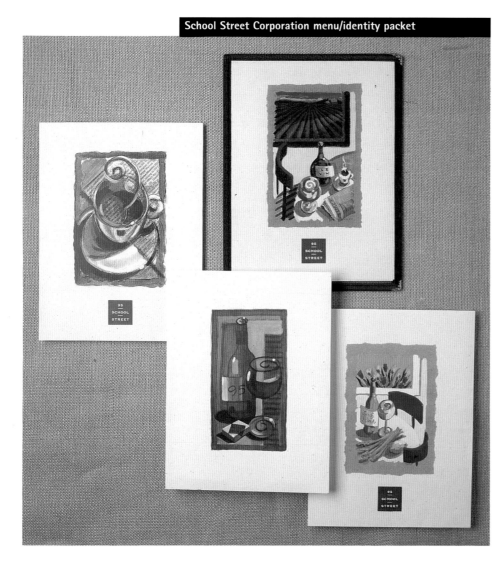

School Street Corporation menu/identity packet

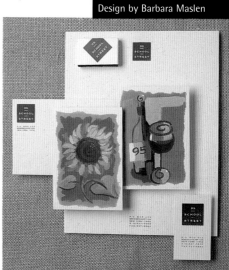

Design by Barbara Maslen

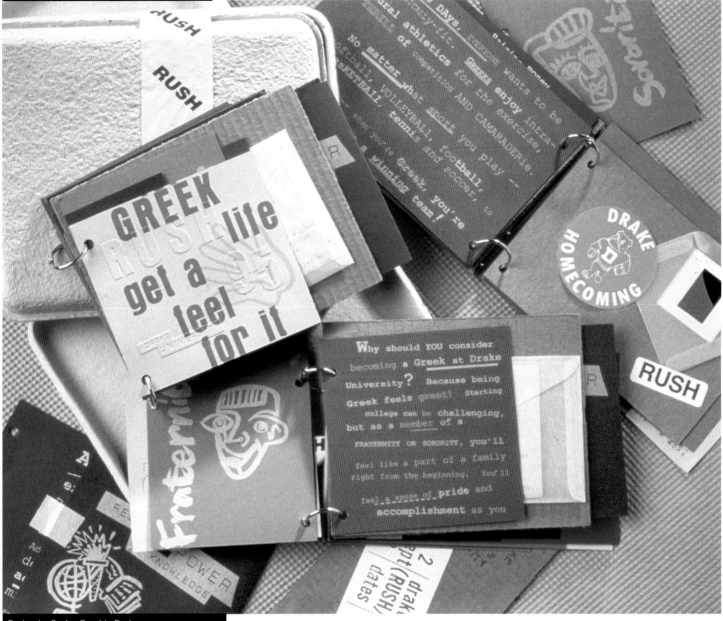

Design by Sayles Graphic Design
All Design: John Sayles

This fraternity/sorority rush mailing has a kind of
young, mildly chaotic charm due to the use of found
materials, including scrap cardboard, paper remnants,
and industrial office supplies.

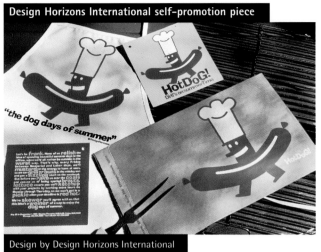

Design Horizons International self-promotion piece

Design by Design Horizons International
All Design: Mike Schacherer

Though only two PMS colors (plus black) were used in printing, the strong graphics, clever copy, and dominant hot-dog theme made this summer self-promotion sizzle.

All the design in this two-color card printed on vellum is created with type. Reversing it out and using halftones, the designers imply that one has to read beyond the surface to discover the real meaning of the holidays.

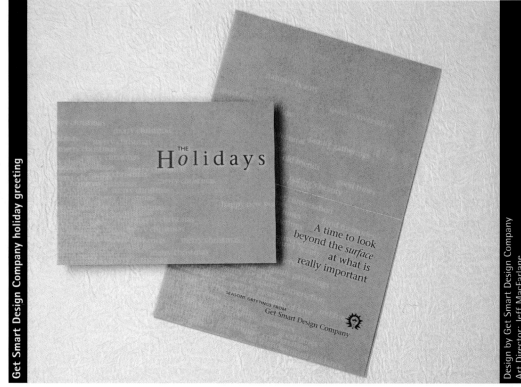

Get Smart Design Company holiday greeting

Design by Get Smart Design Company
Art Director: Jeff MacFarlane
Designer: Tom Culbertson

We're living out of boxes. our temporary address is:

COMPANY AFTER HOURS
ADDRESS 3508 N. 7TH ST.
CITY PHOENIX ST AZ ZIP 85012
PHONE 256-2648 FAX 256-6422

This creative firm forgot to send out a moving notice in advance of the fact, so, showing that necessity is indeed the mother of invention, these moving notices were created from ripped-up moving boxes that were rubber stamped and handwritten.

Much of the power and emotion conveyed by this brochure is the result of simplicity: simple graphics and type, a simple two-color printing process, and blind embossing. The embossing and die cutting were created on a single template to cut costs.

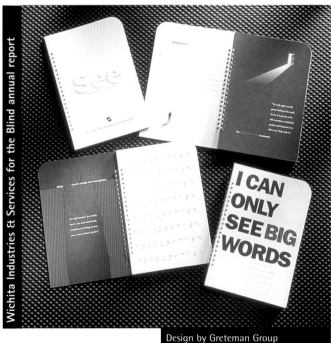

I CAN ONLY SEE BIG WORDS

Design by Greteman Group
Art Director: Sonia Greteman
Designer/Illustrator: James Strange

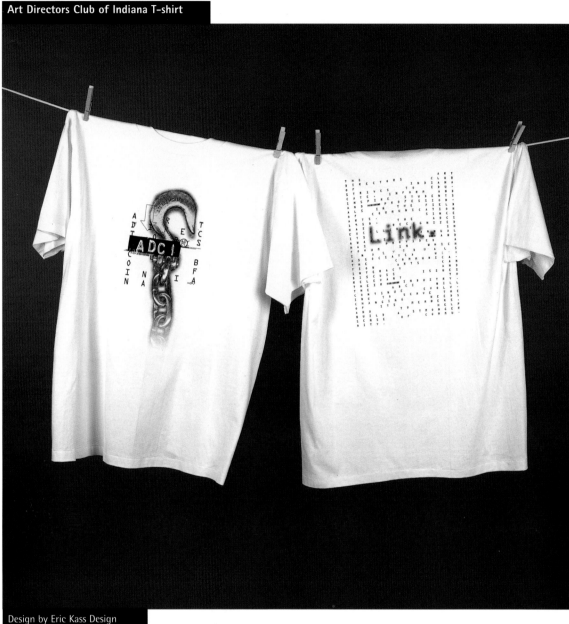

Design by Eric Kass Design
All Design: Eric Kass

This design forges the idea that each member of ADCI is a link in a chain; the one-color printing process made it inexpensive to produce.

This letterhead has an almost electric look, thanks to a Machine Age-style logo and the power of vibrant two-color red and black printing.

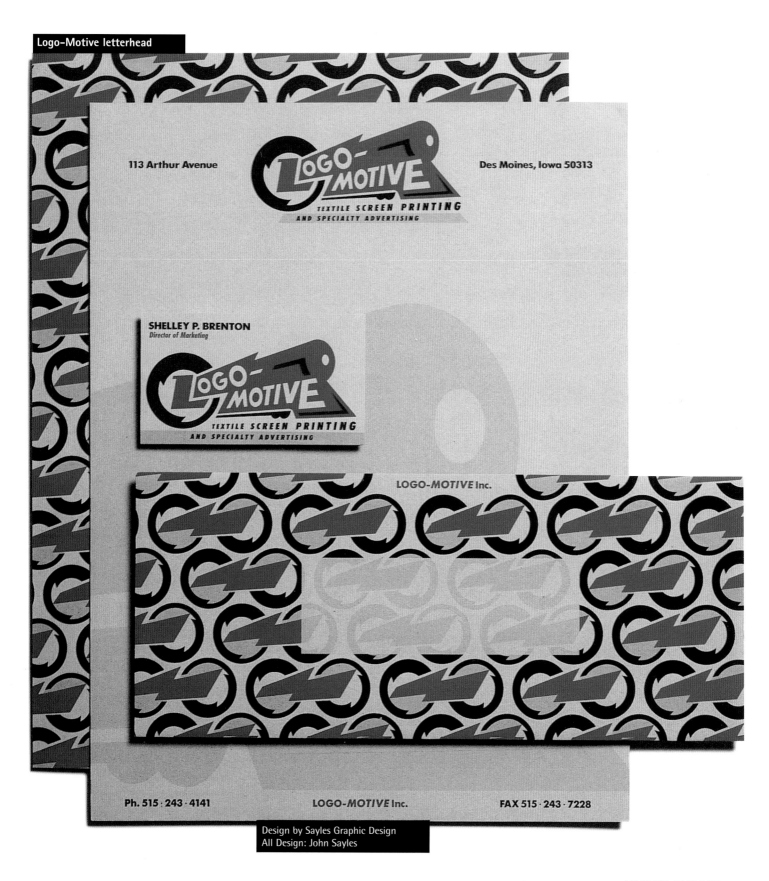

Logo-Motive letterhead

113 Arthur Avenue

LOGO-MOTIVE
TEXTILE SCREEN PRINTING
AND SPECIALTY ADVERTISING

Des Moines, Iowa 50313

SHELLEY P. BRENTON
Director of Marketing

LOGO-MOTIVE
TEXTILE SCREEN PRINTING
AND SPECIALTY ADVERTISING

LOGO-*MOTIVE* Inc.

Ph. 515 · 243 · 4141 LOGO-*MOTIVE* Inc. FAX 515 · 243 · 7228

Design by Sayles Graphic Design
All Design: John Sayles

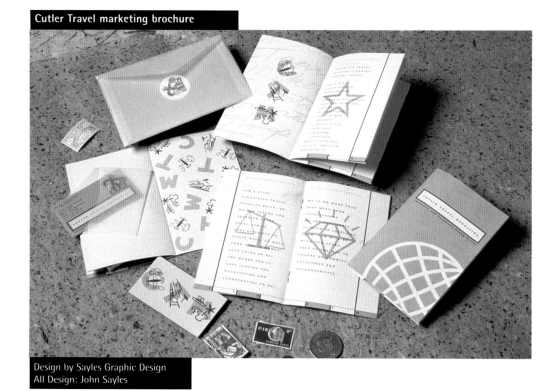

Design by Sayles Graphic Design
All Design: John Sayles

This introductory brochure is printed in two colors on a text-weight paper; it is mailed in a lightweight glassine envelope, so the company saves money not only on printing but on mailing these pieces.

Designed for a free publication, this advertising reminder card had to be produced quickly and inexpensively. The designer used art from his collection of vintage matchbooks, then had the piece printed one color by a quick-print shop.

The Rocket advertising mailing card

THE ROCKET
2028 5th Ave.
Seattle, WA 98121
(206) 728-7625
(503) 228-4702

YOUR INTEREST IS THE HEART of Our BUSINESS

DON'T WALK-TALK

We Are As Near To You As Your Phone

MARCH 1992 ISSUE
Space Reservation Deadline: Wednesday, 2/19
Camera Ready Deadline: Friday, 2/21
Issue on the Stands: Friday 2/28

TheRocket

All Design: Art Chantry

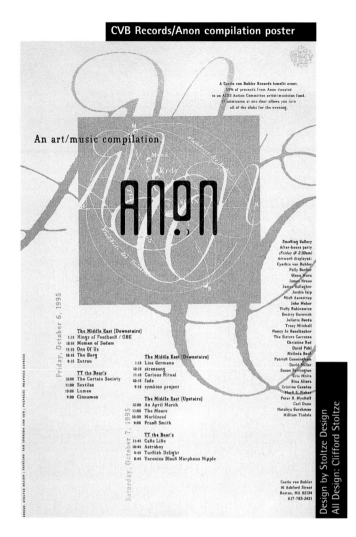

This poster was part of an extravagant CD/art package; to keep the overall budget under control, the poster was printed in one color—a metallic gold ink that gave the design a feeling of contemporary luxury.

The designer produced this self-promotion book entirely in-house and printed it on an HP 600-dpi laser printer. The books can be produced in quantities from one to fifteen at a time at a cost of about three dollars each.

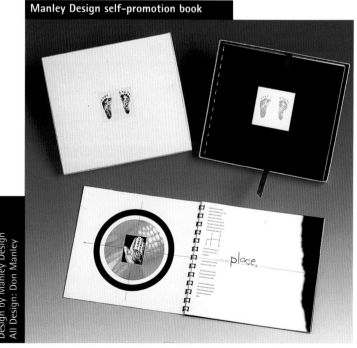

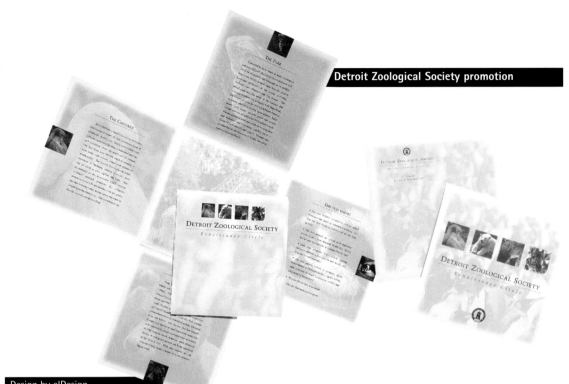

Design by elDesign
Art Director/Designer: Lynn St. Pierre

To produce this multi-piece invitation on a minuscule budget, the designer utilized all her money-saving skills. Clip art, stock photography provided by the client, and donated Cougar Opaque paper all came together beautifully for this elegant, two-color mailer.

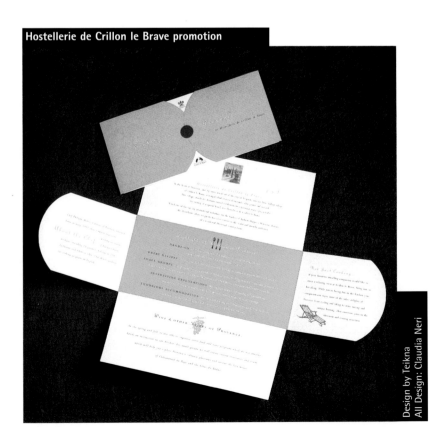

Hostellerie de Crillon le Brave promotion

Design by Teikna
All Design: Claudia Neri

With a very small budget, this mailer was intended to create interest in an elite cooking seminar held in Provence, France. By printing it in two sunny colors, the designer was able to budget in die cutting, which allowed the invitation to unfold like a flower.

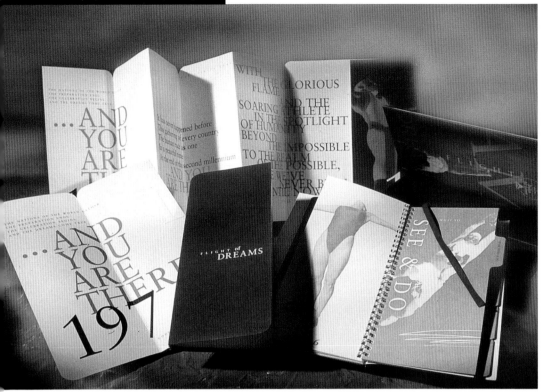

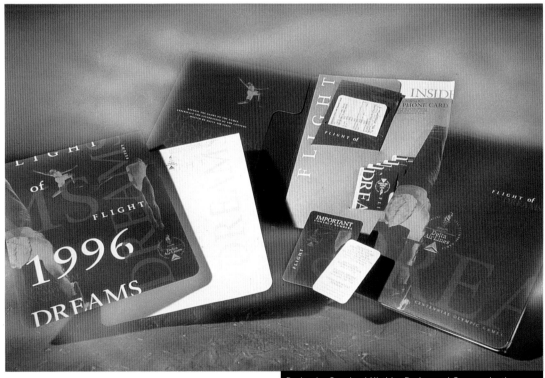

Design by Copeland Hirthler Design and Communications
Creative Directors: Brad Copeland, George Hirthler
Art Director/2D Design: David Butler

To create a piece that would stay within budget while capturing the
Olympic spirit, the designers used potent typography and photography
and printed in two colors on various papers.

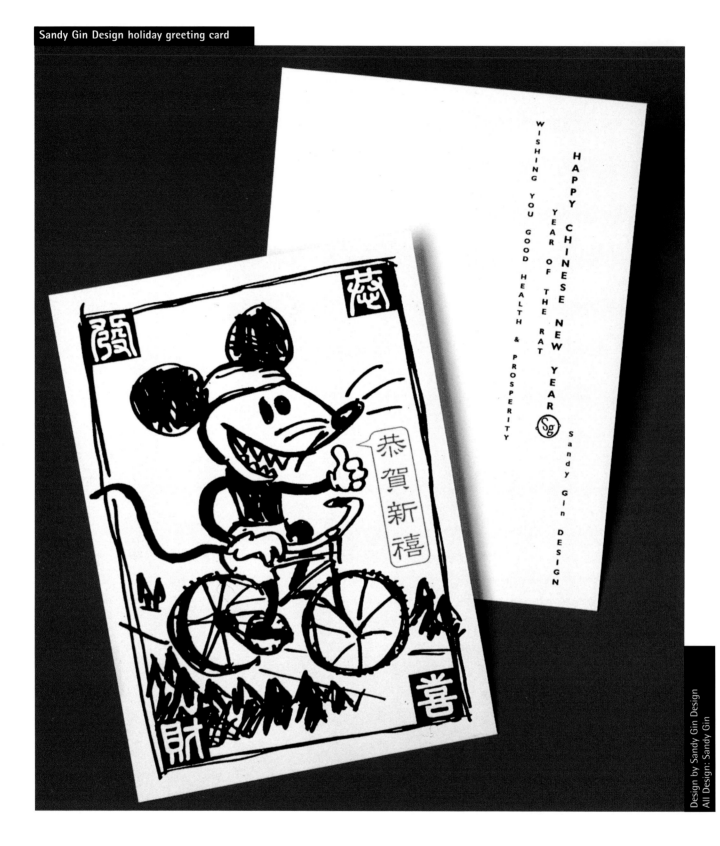

The year of the rat gave the designer potent inspiration for combining

traditional Chinese and contemporary Western imagery. Drawn in felt-tip

marker, the card was reproduced on a color photocopier.

This invitation/poster for an art exhibit is printed on newsprint in one color and folded. This resourceful approach made it not only inexpensive to produce, but lightweight and inexpensive to mail.

Laguna Art Museum exhibit opening mailer

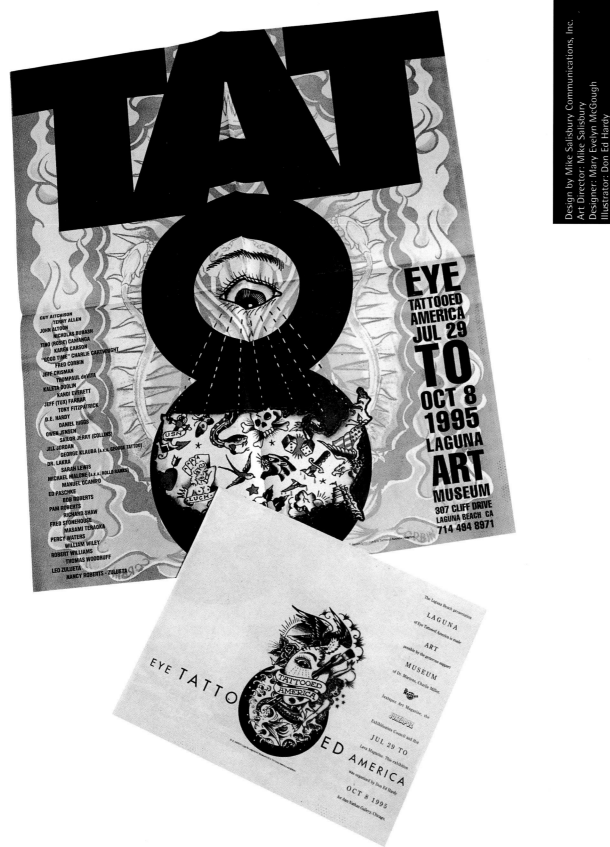

Design by Mike Salisbury Communications, Inc.
Art Director: Mike Salisbury
Designer: Mary Evelyn McGough
Illustrator: Don Ed Hardy

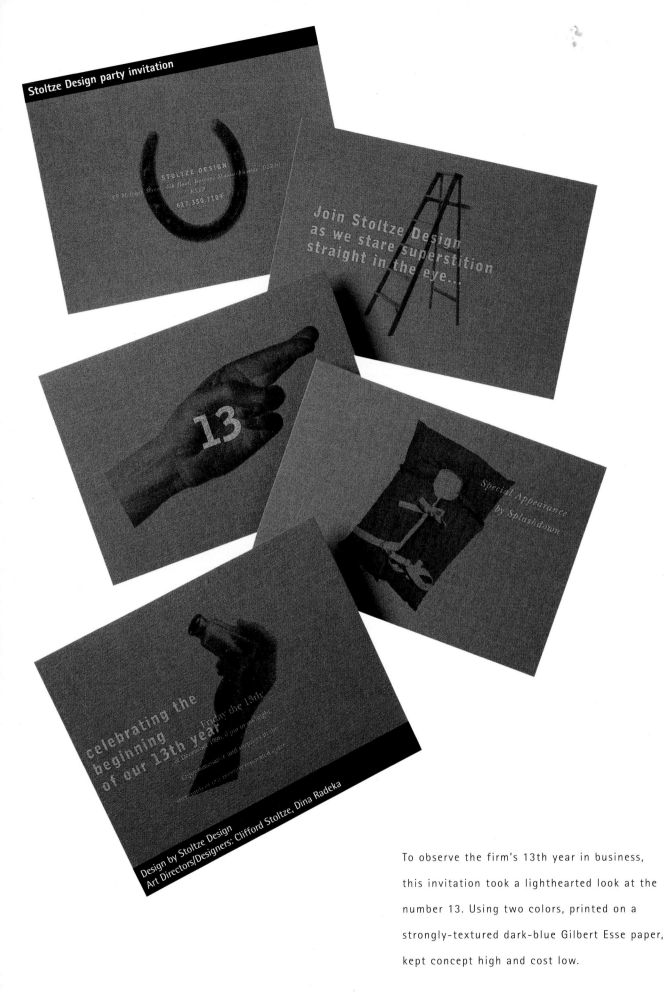

STOLTZE DESIGN
49 Melcher Street, 5th floor, Boston, Massachusetts 02210
RSVP
617.350.7109

Join Stoltze Design
as we stare superstition
straight in the eye...

13

Special Appearance
by Splashdown

celebrating the
beginning
of our 13th year
Friday the 13th
at December 1996, 6 pm to midnight
Refreshments and surprises at the
unveiling of our recently renovated space

Design by Stoltze Design
Art Directors/Designers: Clifford Stoltze, Dina Radeka

To observe the firm's 13th year in business,
this invitation took a lighthearted look at the
number 13. Using two colors, printed on a
strongly-textured dark-blue Gilbert Esse paper,
kept concept high and cost low.

To keep costs down on this wedding invitation (only 100 were produced), this designer did things the old-fashioned way—by hand. Slots are hand-cut, the ribbon and aluminum ring were hand-assembled, and the cherubs hand-colored with pencil. Most of the art was found in a copyright-free illustration book.

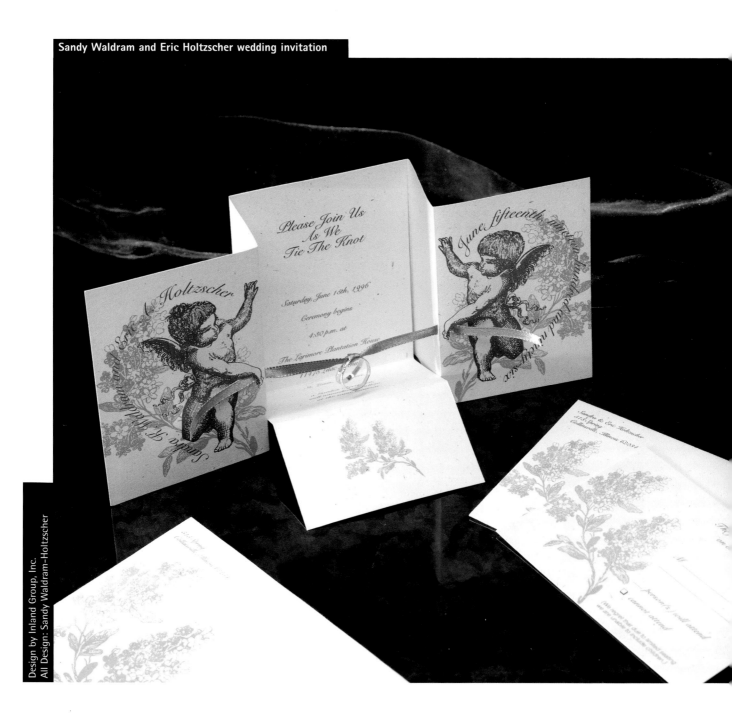

Sandy Waldram and Eric Holtzscher wedding invitation

Design by Inland Group, Inc.
All Design: Sandy Waldram-Holtzscher

This illustrator likes each holiday card to be a limited-edition art piece. By laser printing in black on an interesting Bandelier environmental paper, then hand-coloring with colored pencils, this goal can be inexpensively achieved.

from the studio of
Paul Stoddard
comes Holiday Greetings
and the wishes for a
Happy and Prosperous
New Year.

All Design: Paul Stoddard

Nostalgic imagery and type style, printed one color on a pale-pink card stock, make for an inexpensive and charming invitation to a surprise birthday party held at a bowling alley.

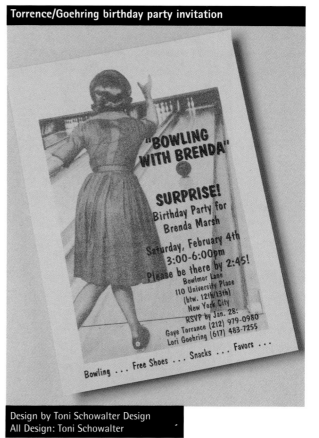

Torrence/Goehring birthday party invitation

"BOWLING WITH BRENDA"

SURPRISE!
Birthday Party for
Brenda Marsh

Saturday, February 4th
3:00-6:00pm
Please be there by 2:45!
Bowlmor Lane
110 University Place
(btw. 12th/13th)
New York City
RSVP by Jan. 28:
Gaye Torrance (212) 979-0980
Lori Goehring (617) 483-7255

Bowling ... Free Shoes ... Snacks Favors ...

Design by Toni Schowalter Design
All Design: Toni Schowalter

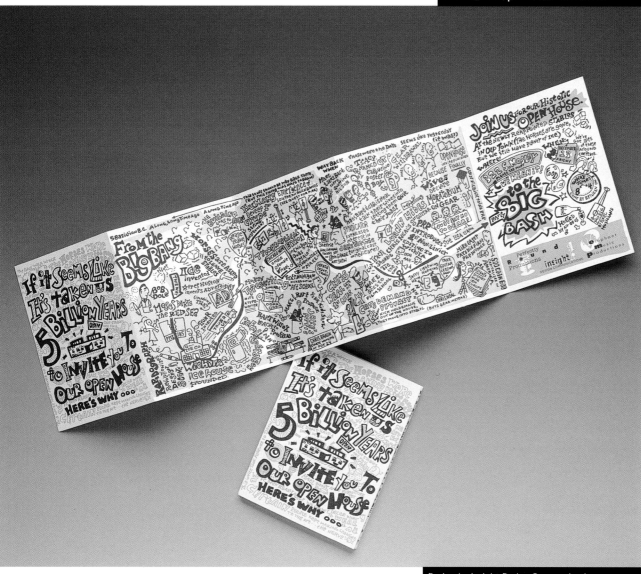

Design by Insight Design Communications
Designers: Sherrie Holdeman, Tracy Holdeman

Good timing accompanied the designers' ingenuity on this project. The printer donated film (they had just gotten a new film-output system) and paper stock, and the designers worked the design to fit on the printer's leftover stock. Additional cost savings were realized through a two-color design printed on one side and accordion folds of equal length to reduce folding costs.

Shook Design Group Valentine's Day Ball invitation

This card was printed in two colors to save the event's budget; the designers made sure that one color had impact, as shown in this romantic design that utilizes discreet touches of metallic gold ink.

Design by Shook Design Group, Inc.
Designers: Ginger Riley, Graham Schulker

Here's a holiday-party invitation/gift that looks extravagant but was accomplished well within budgetary restraints. The two-color invitation is printed on one sheet on an indigo press; the client hand-assembled the packages.

Lori Wilson holiday party invitation

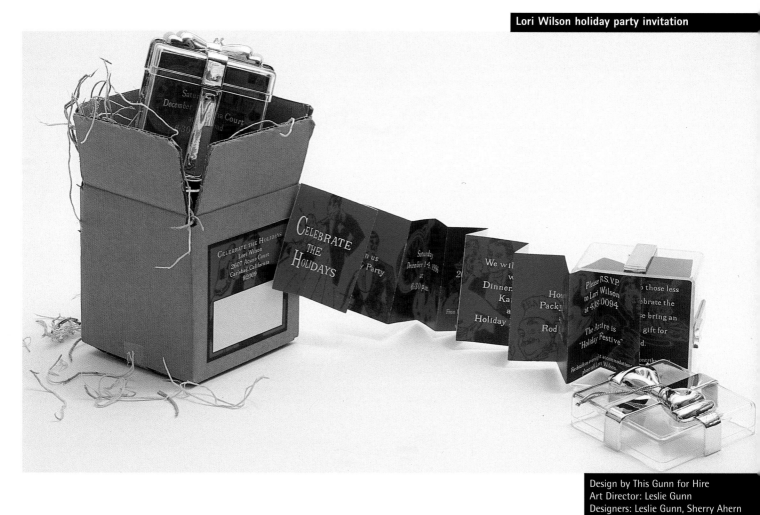

Design by This Gunn for Hire
Art Director: Leslie Gunn
Designers: Leslie Gunn, Sherry Ahern

Design by Design Horizons International
Art Director: Kim Reynolds
Designers: Kim Reynolds, Mike Schacherer
Illustrator: Krista Ferdinand

This holiday self-promotion/gift is a seasonally appropriate parcel of wrapping paper, printed one color on lightweight 50-lb. French newsprint and 60-lb. metallic foil paper to save on printing and mailing costs.

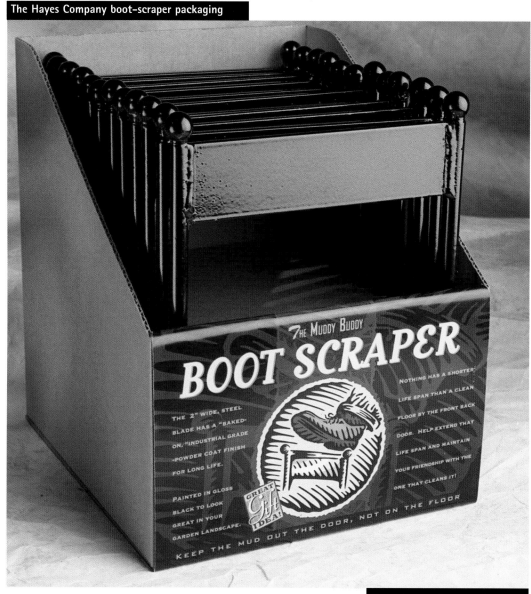

THE MUDDY BUDDY

BOOT SCRAPER

THE 2" WIDE, STEEL
BLADE HAS A "BAKED-
ON, "INDUSTRIAL GRADE
-POWDER COAT FINISH
FOR LONG LIFE.

PAINTED IN GLOSS
BLACK TO LOOK
GREAT IN YOUR
GARDEN LANDSCAPE.

NOTHING HAS A SHORTER
LIFE SPAN THAN A CLEAN
FLOOR BY THE FRONT BACK
DOOR. HELP EXTEND THAT
LIFE SPAN AND MAINTAIN
YOUR FRIENDSHIP WITH THE
ONE THAT CLEANS IT!

GREAT Gift IDEA!

KEEP THE MUD OUT THE DOOR, NOT ON THE FLOOR

Design by Love Packaging Group
All Design: Tracy Holdeman

The designer cleverly created a point-of-purchase
display that would hold a number of boot scrapers
and require only a single box and litho label.

This shopping bag uses an inexpensive two-color process to extreme advantage. The store's name in reversed type and duotones of available merchandise on the bag's sides give it a look of contemporary, restrained good taste.

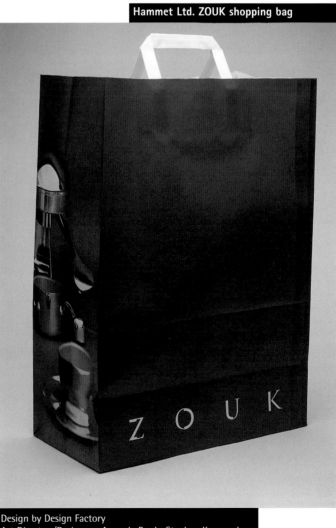

Hammet Ltd. ZOUK shopping bag

Design by Design Factory
Art Directors/Designers: Amanda Brady, Stephen Kavanagh

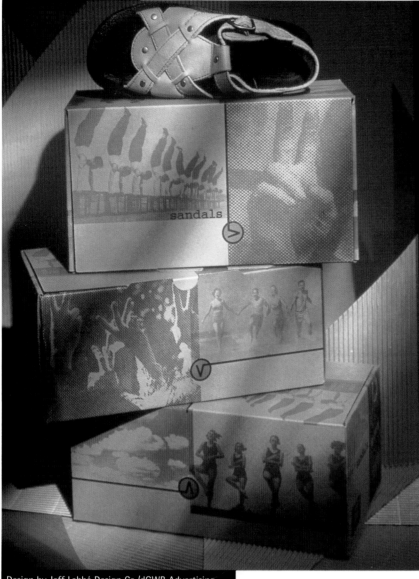

Shimano Bicycling tags

sandals

Design by Jeff Labbé Design Co./dGWB Advertising
All Design: Jeff Labbé

The lean, aggressive, urban design of these tags is ideal for this bicycle company's line of shoes. The designer used just two colors, reversed out one half of the image, and laminated the tags so that prices can be erased and rewritten for sales and promotions.

The designer created this simple, evocative letterhead with the client's assets and liabilities in mind; the non-profit organization doesn't have much of a budget, but they do have their own in-house press. It is printed on Neenah Classic Crest recycled.

American Heart Association I-Love-Paris letterhead

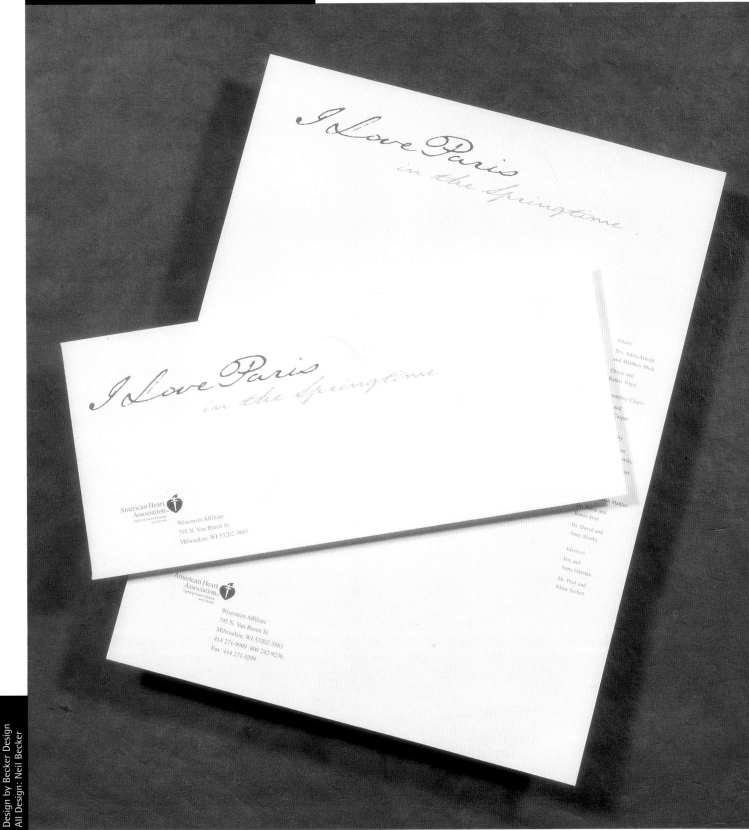

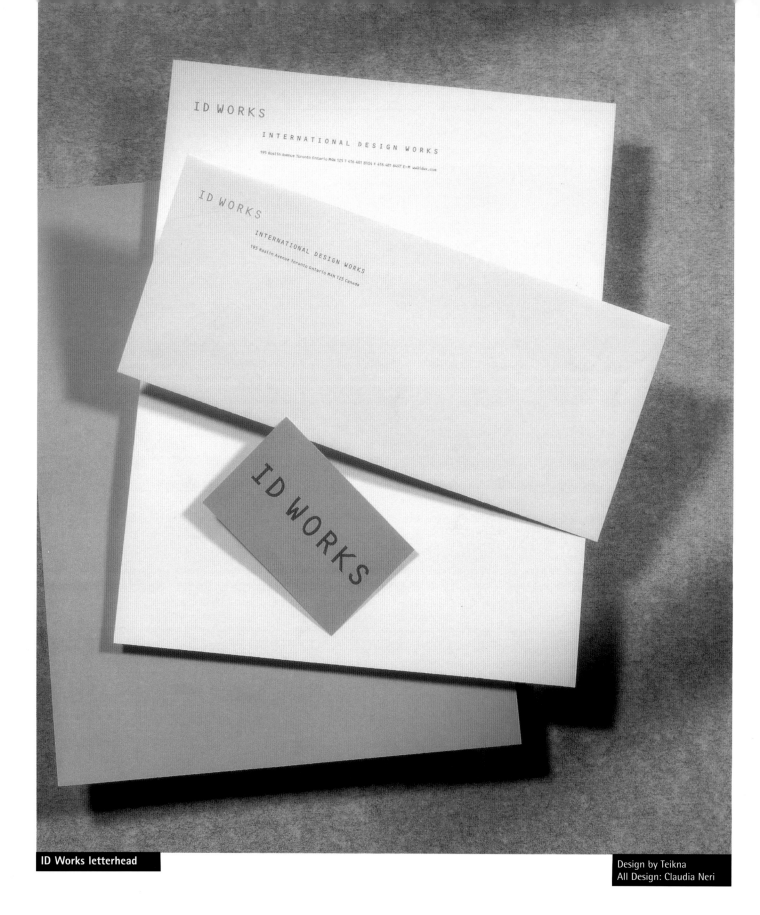

ID Works letterhead

Design by Teikna
All Design: Claudia Neri

To make this letterhead much bigger and bolder than its small budget, the designer

chose to use two subtly complementary colors and strong, spare, ultra-modern type.

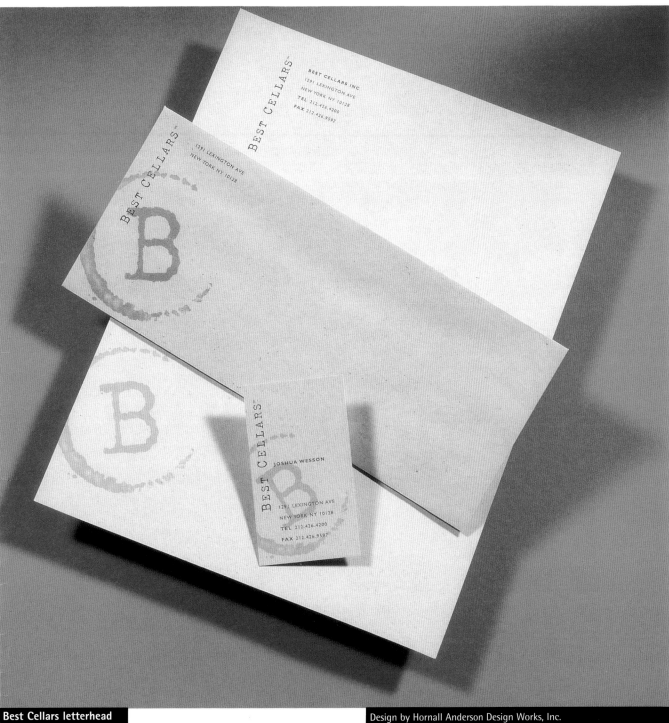

Best Cellars letterhead

Design by Hornall Anderson Design Works, Inc.
Art Director: Jack Anderson
Designers: Jack Anderson, Lisa Cerveny, Jana Wilson, David Bates

Simple, earthy, and to-the-point, this letterhead
displays a logo that appears to be a ring created by
a glass of red wine. The piece is printed in one
color on a recycled stock.

The unusual placement of the envelope flap, plus the reserved stripe on the flap, business card, and back of the letterhead, has a sleek and elegant look that belies the one-color printing.

Debra Roberts and Associates letterhead

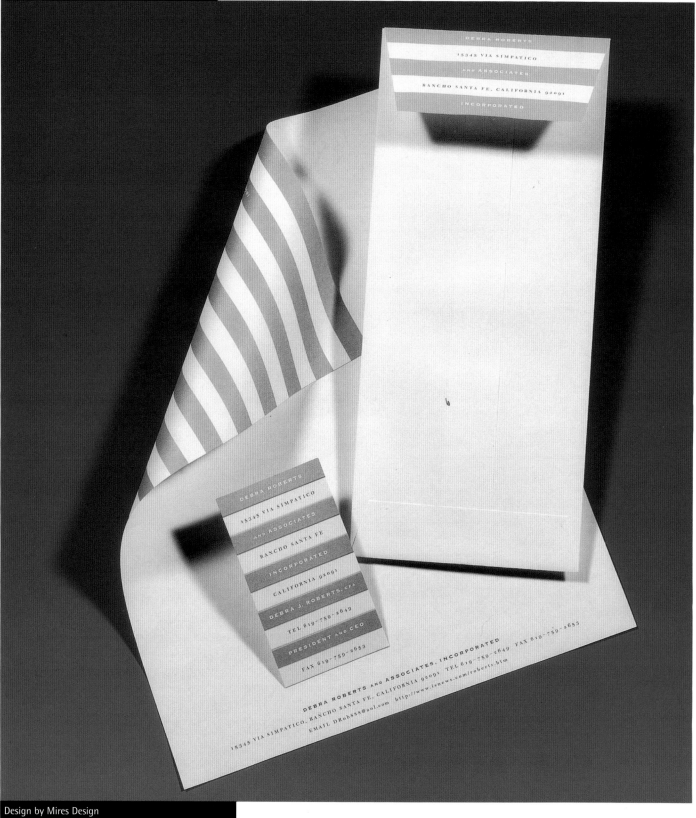

Design by Mires Design
Art Directors/Designers: Scott Mires, Deborah Horn

This two-color design, printed on an oxford-style paper, not only came in on budget but reflects the enthusiastic nature of the client and graphically draws attention to her last name with the color gray.

Kristi Gray, Inc. letterhead

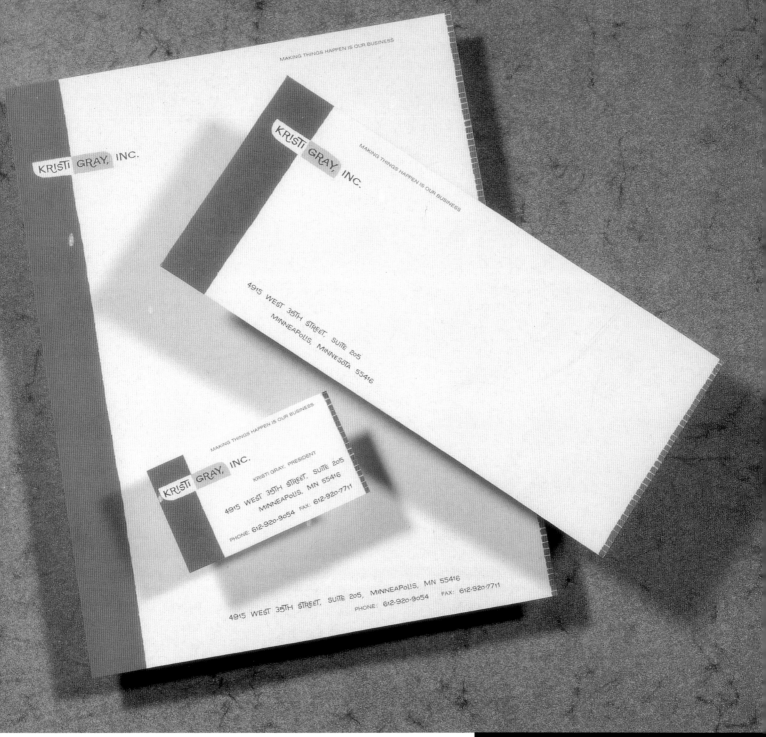

MAKING THINGS HAPPEN IS OUR BUSINESS

KRISTI GRAY, INC.

KRISTI GRAY, INC.

MAKING THINGS HAPPEN IS OUR BUSINESS

4915 WEST 35TH STREET, SUITE 205
MINNEAPOLIS, MINNESOTA 55416

MAKING THINGS HAPPEN IS OUR BUSINESS

KRISTI GRAY, INC.

KRISTI GRAY, PRESIDENT
4915 WEST 35TH STREET, SUITE 205
MINNEAPOLIS, MN 55416
PHONE: 612-920-9054 FAX: 612-920-7711

4915 WEST 35TH STREET, SUITE 205, MINNEAPOLIS, MN 55416
PHONE: 612-920-9054 FAX: 612-920-7711

Design by Zauhar Design
All Design: David Zauhar

The Constructivist appeal of
this card was pragmatically
accomplished on a low
budget; printed in one color,
the designer used three types
of duplexes, which were
flipped to create six
variations. This made the
choice of spending money on
a 120-lb. card stock possible.

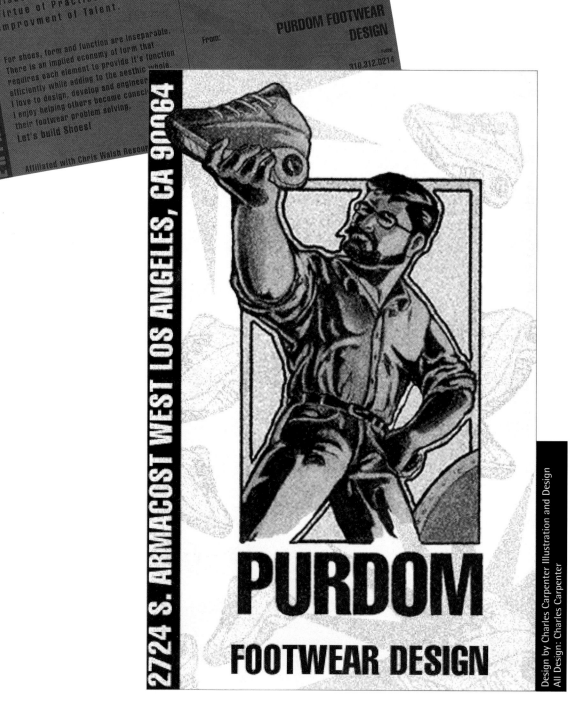

The Value of Time.
Success of Perseverance.
Dignity of Simplicity.
Worth of Character.
Power of Kindness.
Influence of Example.
Obligation of Duty.
Wisdom of Economy.
Virtue of Practice.
Improvment of Talent.

For shoes, form and function are inseparable.
There is an implied economy of form that
requires each element to provide it's function
efficiently while adding to the aesthic whole.
I love to design, develop and engineer shoes.
I enjoy helping others become conscious of
their footwear problem solving.
Let's build Shoes!

Affiliated with Chris Walsh Resources

ERIK PURDOM CRAFTSMAN

Purdom Footwear Design promotional mailer

To:

From:

PURDOM FOOTWEAR
DESIGN

PHONE
310.312.0214

2724 S. ARMACOST WEST LOS ANGELES, CA 90064

PURDOM

FOOTWEAR DESIGN

Design by Charles Carpenter Illustration and Design
All Design: Charles Carpenter

These direct-response cards, sent out to prospective clients, feature bold, woodcut-style illustrations that really utilize single-color printing to advantage.

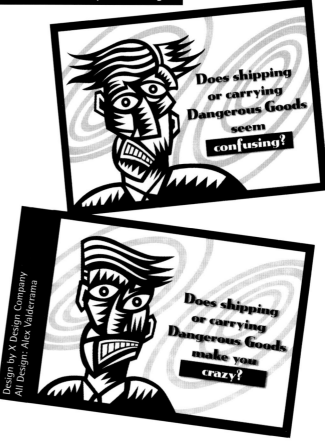

Does shipping or carrying **Dangerous Goods** seem **confusing?**

Does shipping or carrying **Dangerous Goods** make you **crazy?**

Design by X Design Company
All Design: Alex Valderrama

This firm creates a new promotional card monthly, so they have to be produced on a modest budget. The two-color printing was used to maximum advantage by printing type in red.

Do you believe in love at first sight?

Great.

When can we show you our latest portfolio?

Happy Valentine's Day from the people you'll love to work with!

Sheaff Dorman Purins
Strategic Thinking and Design

Voice: 617.449.0602
sheaff@tiac.net
Fax: 617.455.8945

Design by Sheaff Dorman Purins
All Design: Uldis Purins

The designer used photography from a stock photo disk and was able to get the paper manufacturer to donate a new style of paper—Utopia from Appleton—to bring this romantic invitation/promotion in on a small budget.

American Heart Association annual Heart Ball promotion

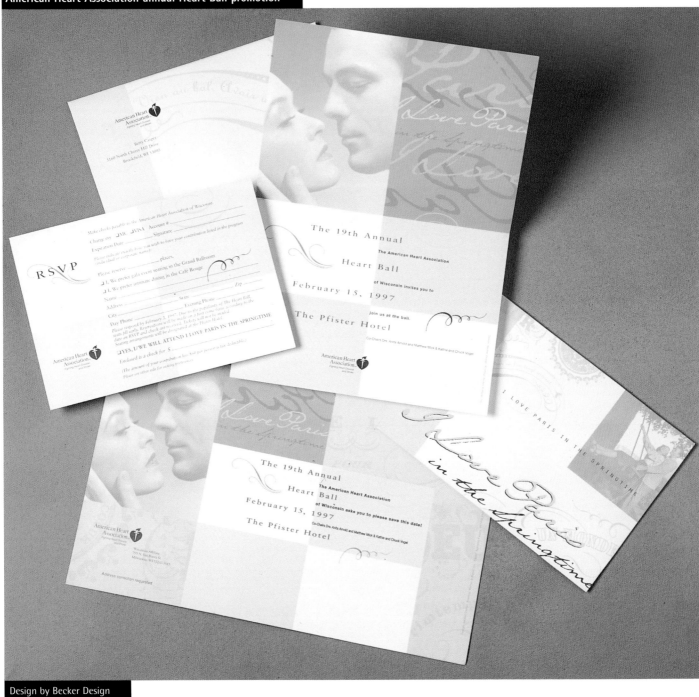

Design by Becker Design
All Design: Neil Becker

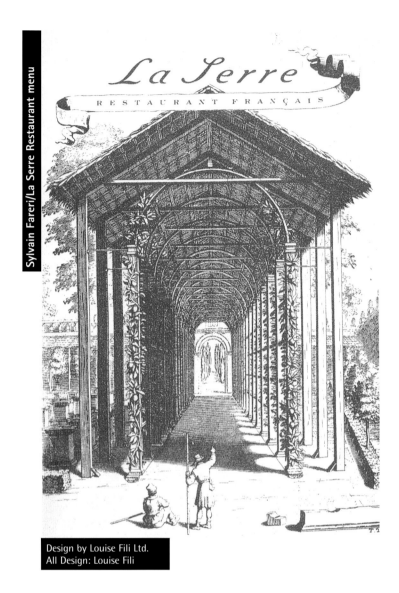

Design by Louise Fili Ltd.
All Design: Louise Fili

La serre means greenhouse in French; using a single color of green ink on cream

parchment and an eighteenth-century image, the designer suggests the relaxed

elegance of this restaurant.

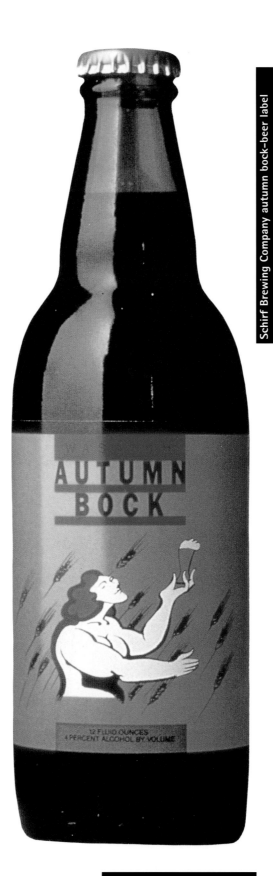

Schirf Brewing Company autumn bock-beer label

This label for a beer that is produced seasonally in very small quantities is printed in three warm, autumnal colors and can be simply and economically affixed onto the company's standard bottles.

Design by The Weller Institute
All Design: Don Weller

Combining two attention-grabbing colors with a design quickly created in Adobe Illustrator, the designers were able to create a distinctive T-shirt that was inexpensive to produce.

East Bay Habitat for Humanity annual buildathon T-shirt

Design by Lead Dog Communications
Designers: Suzanne Jacquot, Anna Kallis

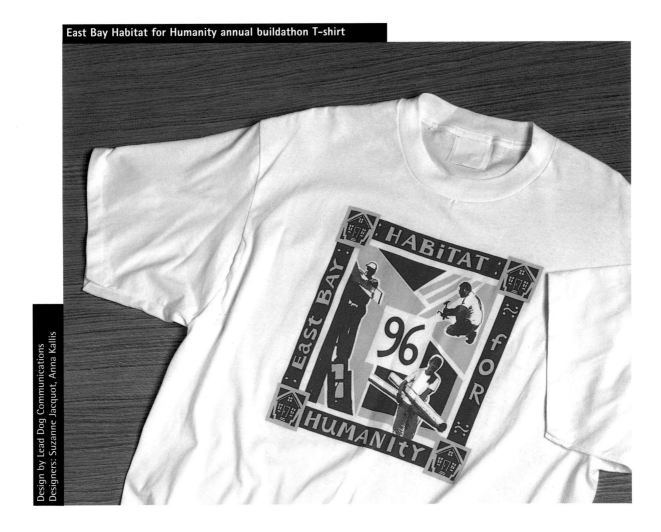

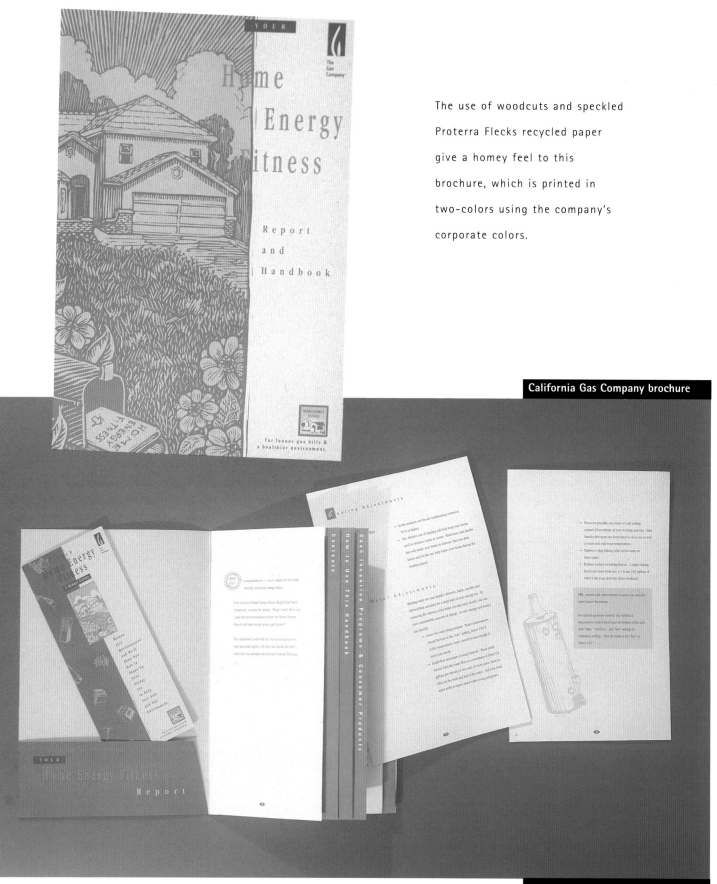

The use of woodcuts and speckled Proterra Flecks recycled paper give a homey feel to this brochure, which is printed in two-colors using the company's corporate colors.

California Gas Company brochure

Design by Julia Tam Design
Art Director/Designer: Julia Chong Tam
Illustrator: Carol O'Malia

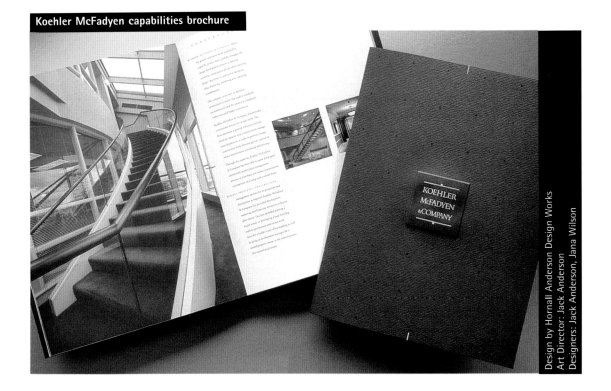

Koehler McFadyen capabilities brochure

Design by Hornall Anderson Design Works
Art Director: Jack Anderson
Designers: Jack Anderson, Jana Wilson

The client wanted to inexpensively create a capabilities brochure that would allow existing project sheets to be inserted. The answer was a richly textured, embossed folder and a one-color cover sheet.

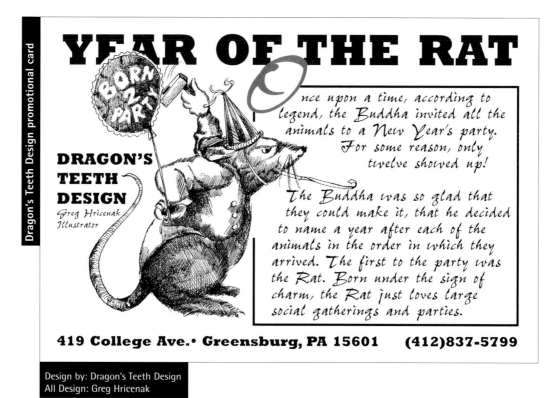

YEAR OF THE RAT

BORN 2 PARTY

DRAGON'S TEETH DESIGN

*Greg Hricenak
Illustrator*

Once upon a time, according to legend, the Buddha invited all the animals to a New Year's party. For some reason, only twelve showed up!

The Buddha was so glad that they could make it, that he decided to name a year after each of the animals in the order in which they arrived. The first to the party was the Rat. Born under the sign of charm, the Rat just loves large social gatherings and parties.

419 College Ave.• Greensburg, PA 15601 (412)837-5799

Design by: Dragon's Teeth Design
All Design: Greg Hricenak

This card features a great pen-and-ink drawing and big, bold type that are destined to look perfect when printed in basic black—the obvious low-budget choice of designers.

A homemade effort that is chic and clever, this gallery creates cards for its monthly mailing using an on-site antique letterpress and black-and-white, pen-and-ink drawings, which are then photocopied onto card stock.

11 Pacific Street Art Gallery mailing

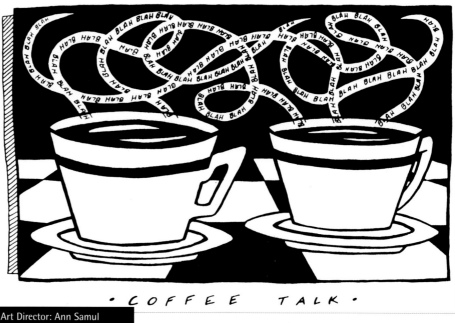

• C O F F E E T A L K •

Art Director: Ann Samul
Illustrator: Gabardine Slax

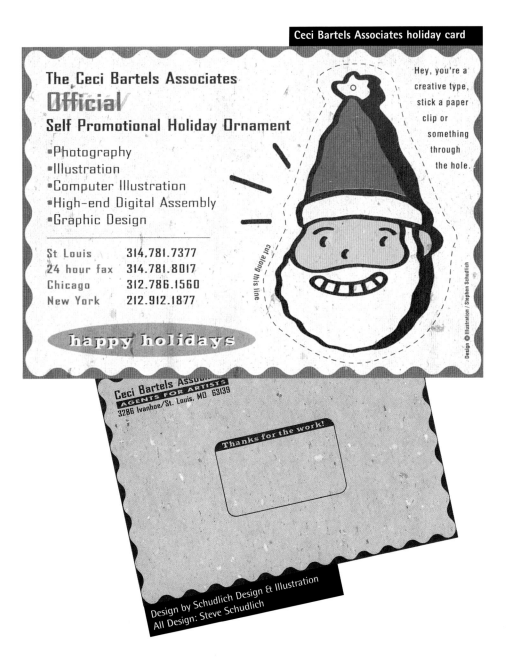

The Ceci Bartels Associates
Official
Self Promotional Holiday Ornament

- Photography
- Illustration
- Computer Illustration
- High-end Digital Assembly
- Graphic Design

St Louis	314.781.7377
24 hour fax	314.781.8017
Chicago	312.786.1560
New York	212.912.1877

happy holidays

Hey, you're a creative type, stick a paper clip or something through the hole.

cut along this line

Design © Illustration / Stephen Schudlich

Ceci Bartels Associates
AGENTS FOR ARTISTS
3286 Ivanhoe/St. Louis, MO 63139

Thanks for the work!

Design by Schudlich Design & Illustration
All Design: Steve Schudlich

This combination holiday card, self-promotion, and Christmas-tree ornament was printed in two colors on sturdy chipboard. The multiple uses, inexpensive printing technique, and small size (4" x 6") of the card enabled the firm to send it to a broad client base.

This invitation to a photographic exhibition creates excitement by placing an image upside-down and setting text in a utilitarian typeface. The designer used a color copier to keep the project under budget.

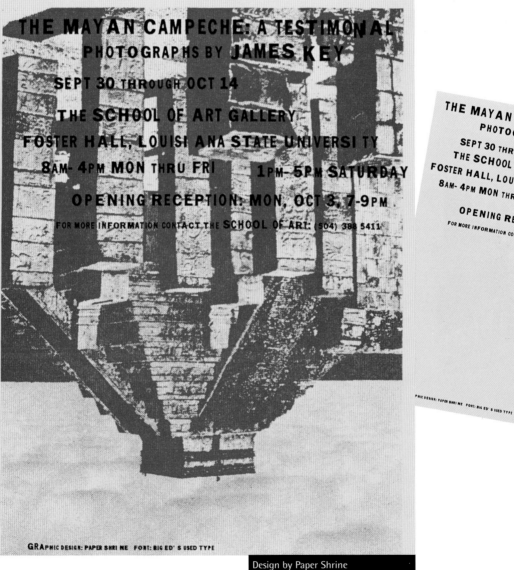

Louisiana State University Art Exhibition announcement

THE MAYAN CAMPECHE: A TESTIMONIAL
PHOTOGRAPHS BY JAMES KEY
SEPT 30 THROUGH OCT 14
THE SCHOOL OF ART GALLERY
FOSTER HALL, LOUISIANA STATE UNIVERSITY
8AM- 4PM MON THRU FRI 1PM- 5PM SATURDAY
OPENING RECEPTION: MON, OCT 3, 7-9PM
FOR MORE INFORMATION CONTACT THE SCHOOL OF ART: (504) 388 5411

GRAPHIC DESIGN: PAPER SHRINE FONT: BIG ED'S USED TYPE

Design by Paper Shrine
Art Director/Designer: Paul Dean

Design by Teikna
Art Director/Designer: Claudia Neri
Illustrator: Fabio Finnocemioli

This opening announcement for an exclusive, all-organic spa in Tuscany had to reflect the historical, traditional, and environmental attributes of the establishment. The choice was recycled paper, printed in two colors.

These holiday cards were produced in-house with a Laserwriter and then hand-ripped and highlighted to appear as if they'd just been torn out of a dictionary.

Design by McGaughy Design
All Design: Malcolm McGaughy

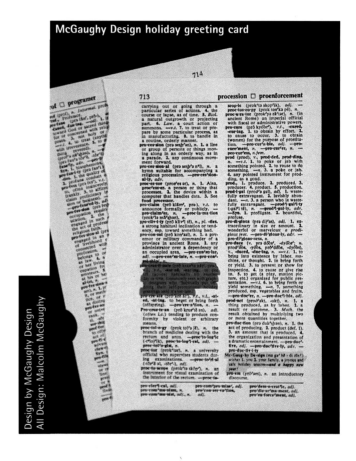

McGaughy Design holiday greeting card

A surplus of free promotional calendars were used and hand-taped onto sepia print posters (from 100 dpi film). Unit cost came in at an impressive ten cents a piece.

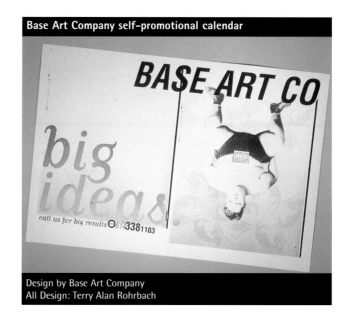

With the initial limitations of having to use an existing illustration and only two colors, the designer relied on strong type and graphics and a Speckletone paper to enrich the design.

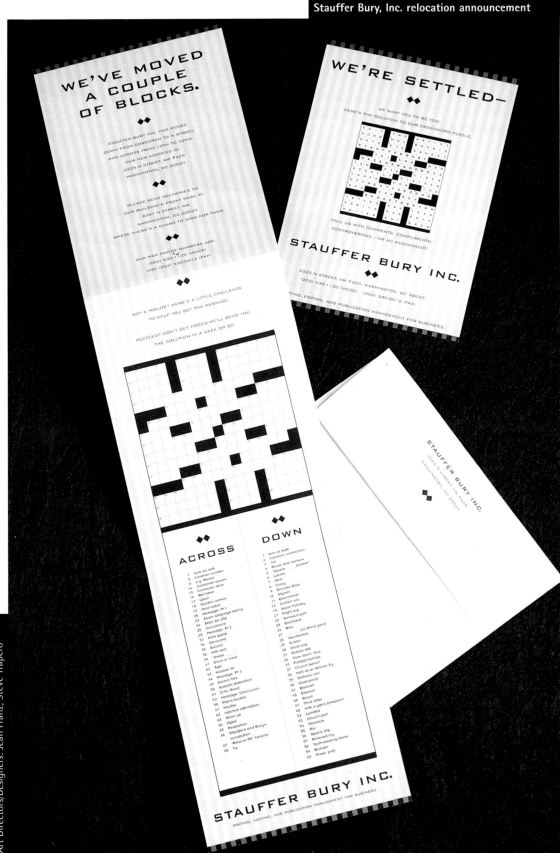

The visual pun of having moved a few blocks is gratifyingly fulfilled in this relocation announcement based on a crossword puzzle. The two-color printing is not only appropriate for the design, but relatively inexpensive.

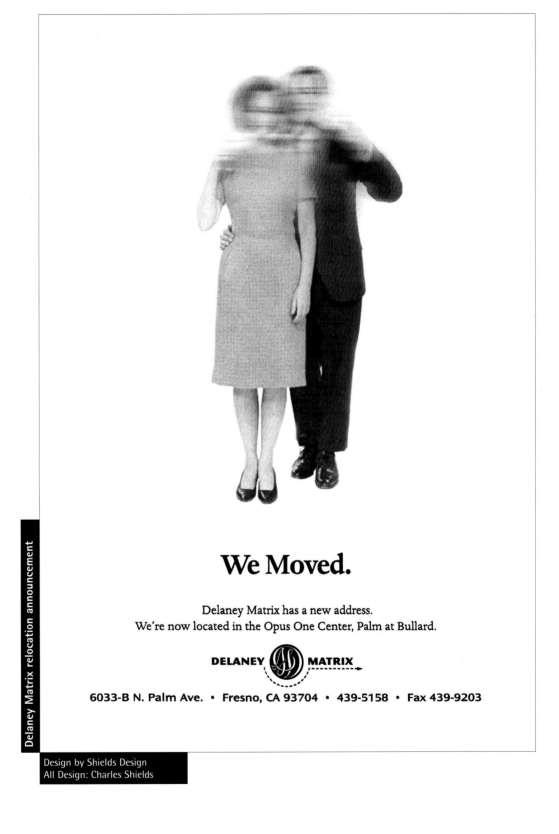

We Moved.

Delaney Matrix has a new address.
We're now located in the Opus One Center, Palm at Bullard.

DELANEY MATRIX

6033-B N. Palm Ave. • Fresno, CA 93704 • 439-5158 • Fax 439-9203

The headline tells the whole story in this
inexpensive one-color relocation
announcement for a husband-and-wife
firm. The designer used Adobe Photoshop
to blur an image of the couple.

The nostalgic appeal of archival line art, combined with a traditional typeface, was printed one-color for this playfully dry birth announcement.

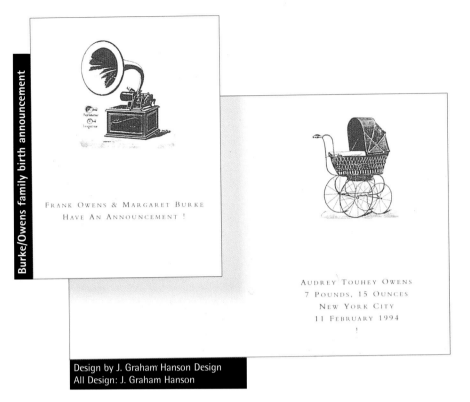

FRANK OWENS & MARGARET BURKE
HAVE AN ANNOUNCEMENT !

AUDREY TOUHEY OWENS
7 POUNDS, 15 OUNCES
NEW YORK CITY
11 FEBRUARY 1994

Design by J. Graham Hanson Design
All Design: J. Graham Hanson

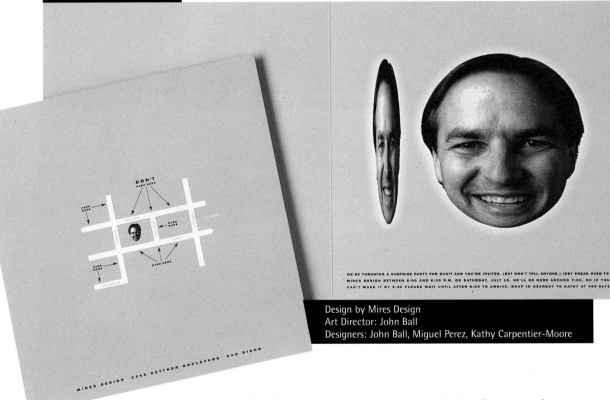

Design by Mires Design
Art Director: John Ball
Designers: John Ball, Miguel Perez, Kathy Carpentier-Moore

This invitation was for a ten-years-in-business surprise anniversary party. Using Adobe Photoshop, the designers distorted a photograph to make the honoree resemble the number 10. While the two-color printing was budget-worthy, it also succeeded in making the images pop.

Jayson Adams
1074 Marcussen Drive
Menlo Park, CA 94025

What
It's time to celebrate
Jayson's birthday (30th!)
and his exit from the
rat race (retirement!).

Where
Jayson's summer home
1074 Marcussen Drive
Menlo Park, CA 94025
322-7978
jayson@shrike.batnet.com

When
Saturday, March 1st, 9pm

But
No buts, just get your ass over here!
And no presents either.
Please RSVP.

How
Take the Willow Road exit west off of 101,
turn right on Middlefield Road, turn left at
Ravenswood Ave. Head up Ravenswood for
one block, and turn right onto Marcussen
Drive. Jayson's house is on the right, about
halfway down the block, between a red
reflector dot thingy and a fire hydrant.

Take the Sand Hill Road exit east off of 280,
turn left on Alameda de las Pulgas. As you
approach the next light, veer to the right,
and continue until you reach the stop sign.
At the stop sign, stop!, and then take a
right onto Santa Cruz Ave. (you'll see a
cemetary on your right). Head up Santa
Cruz, turn right onto El Camino and quickly
get into the left-hand turn lane, then turn
left onto Ravenswood Ave. Cross the tracks,
go through the light, and get ready to
make a left onto Marcussen Drive. The
turn's hard to see at night—look for a blue
post box along the right side of the road.
Jayson's house is on the right, about
halfway down the block, between a red
reflector dot thingy and a fire hydrant.

Design by Stowe Design
Designer: Jennifer Alexander

The use of halftones, photography, and computerized illustration enliven
this simple invitation and describe the dual nature of the event—a 30th
birthday party/retirement (from the rat race) party.

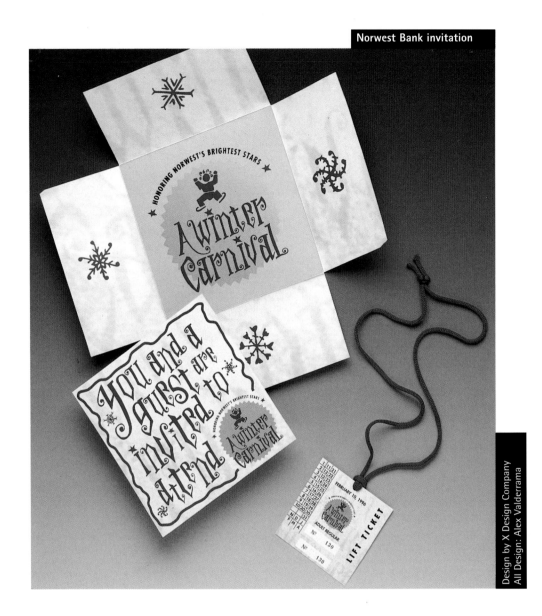

Hand-lettering, snowflake graphics, a special fold, and a texturized background
maximize the impact of this two-color invitation, which included a perforated
lift ticket that carried out the winter-carnival theme.

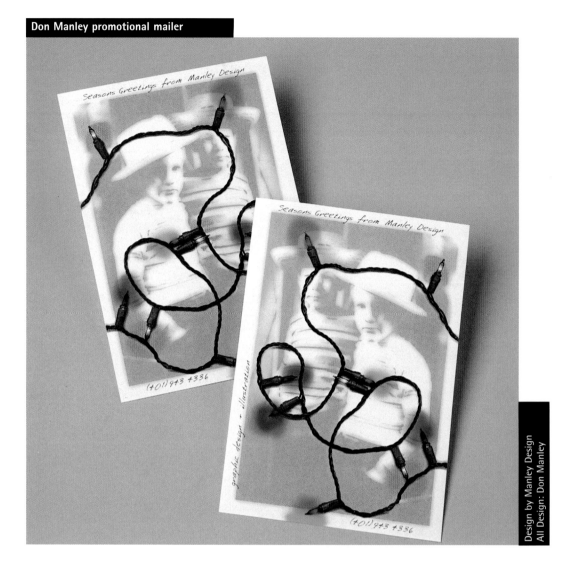

Design by Manley Design
All Design: Don Manley

The designer sends out promotional mailers several times a year; this postcard was produced in-house using an HP 300-dpi color ink-jet printer. The fun, lighthearted approach elicited a very positive response.

This artist's agency has been in business since 1917; the new stationery, printed two-color on recycled stock, uses halftone illustrations with a jazz-age feel to recall not only the agency's history, but its sense of fun.

Curt Richter Fania letterhead

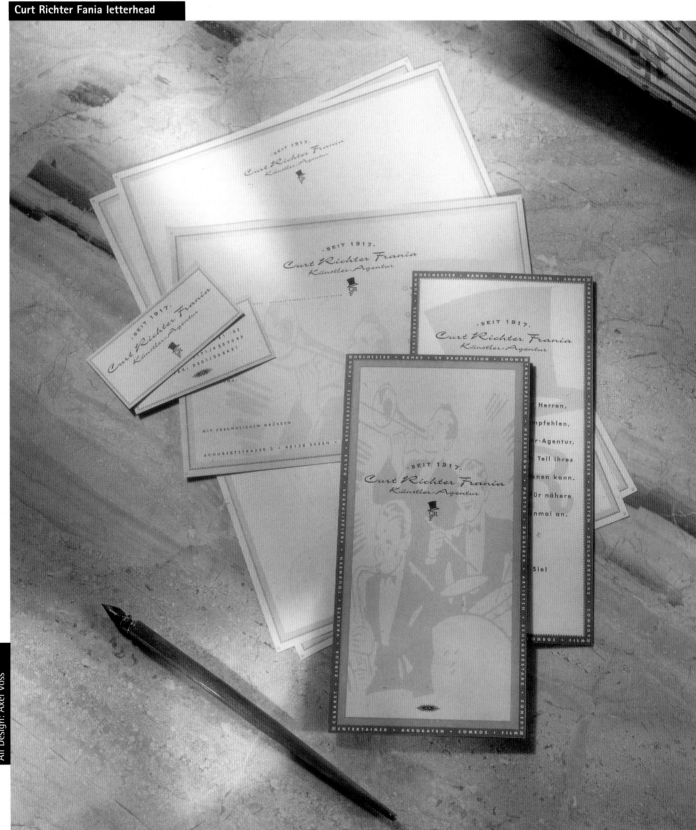

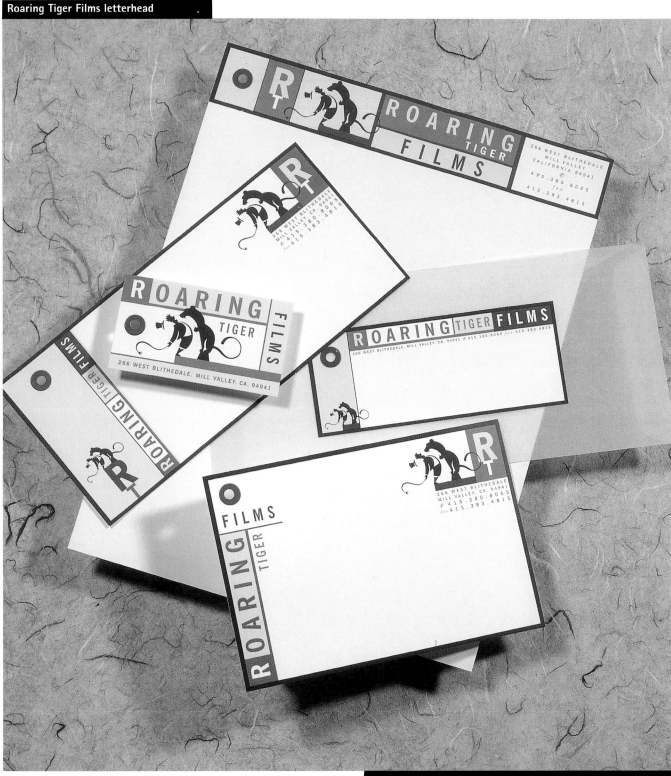

Design by Dogstar
Art Director: Jennifer Martin
Designer/Illustrator: Rodney Davidson

The designer wanted this lively design to include

five different colors. By using black in various tones

plus yellow and brown, the original design keeps

its dynamic quality with only three colors of ink.

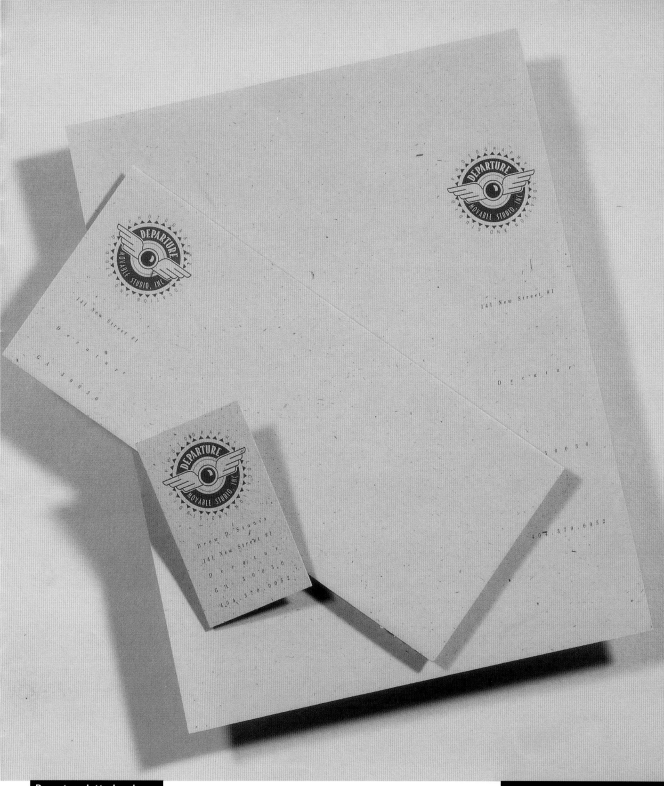

Departure letterhead

Design by Icehouse Design
Art Director: Pattie Belle Anderson
Designer/Illustrator: Bjorn Akselsen

This nostalgic logo design recalls aerial barnstorming and includes a camera lens to indicate the company's specialty in location photography. The two-color design is printed on a vintage color of French Speckletone paper to uphold the overall feel of the piece.

This die-cut card was perfect for the design firm's one-year anniversary, which occurs on the US's Independence Day. Two-color printing kept the project within budget; in fact, response was so great the card paid for itself within a week of being mailed.

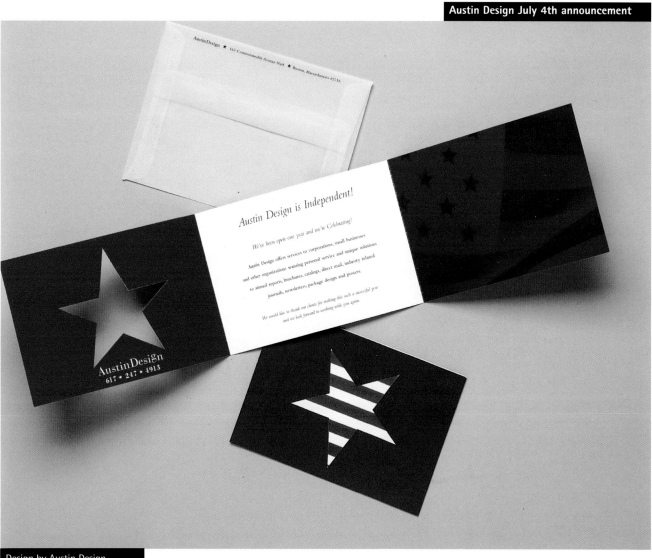

Austin Design is Independent!

We've been open one year and we're Celebrating!

Austin Design offers services to corporations, small businesses and other organizations wanting personal service and unique solutions to annual reports, brochures, catalogs, direct mail, industry related journals, newsletters, package design and posters.

We would like to thank our clients for making this such a successful year and we look forward to working with you again.

AustinDesign
617 ★ 247 ★ 4913

Design by Austin Design
All Design: Wendy Austin

Identity crisis? A graphic identifier is the visual expression of the essence of an organization.

Please call to see a portfolio of our graphic communications tailored to your needs.

Toni Schowalter Design Tel 212 727 0072 Fax 212 727 0071

From left: HMA, executive search company ; Easy Link, computer mailbox; Zetek, fire control symbol; Star, a newsletter masthead; MWI, Marshall Watson Interiors.

Image differentiation.

Includes a variety of elements working together to create a singular, impactful, and memorable impression.

Please call to see a portfolio of our graphic communications tailored to your needs.

Toni Schowalter Design Tel 212 727 0072 Fax 212 727 0071

From left: Symbol for flexible savings; Judy Freedman, yoga instructor; Symbol for telephone access; Interior Business Furniture Group; SAGE, financial investments; Junior League logotype.

What's in a name?

A good name provides the foundation from which to build a unique and successful identity.

Please call to see a portfolio of our graphic communications tailored to your needs.

Toni Schowalter Design Tel 212 727 0072 Fax 212 727 0071

From left: Spirulina, Cosmetic Brand; FocalPoint, a newsletter; Rare Wine Auction; Vitamin Works, a retail store; Fun Works, a Johnson & Johnson's employee committee.

Graphic Identifier. The unique visual characteristics that set one company apart from another.

Please call to see a portfolio of our graphic communications tailored to your needs.

Toni Schowalter Design Tel 212 727 0072 Fax 212 727 0071

From left: MorseDiesel, construction management ; CFI, furniture dealer; IAWCR, proposed logo; HealthShore, employee newsletter for Nabisco Brands; Spirulina, proposed cosmetics logo; Paddlemania, Beacon Hill Club event.

The interesting horizontal shape of these self-promotion cards optimized the designer's ability to show off logos done for current clients and made the frugal choice of two PMS colors really work.

With a keep-it-simple philosophy, this holiday card was produced in two inexpensive versions. Both feature one-color type and hand-applied holiday stickers. The computer-generated version was for corporate clients, while the majority of cards were laser-printed onto kraft paper and mounted on corrugated board.

D4 Creative Group holiday greeting

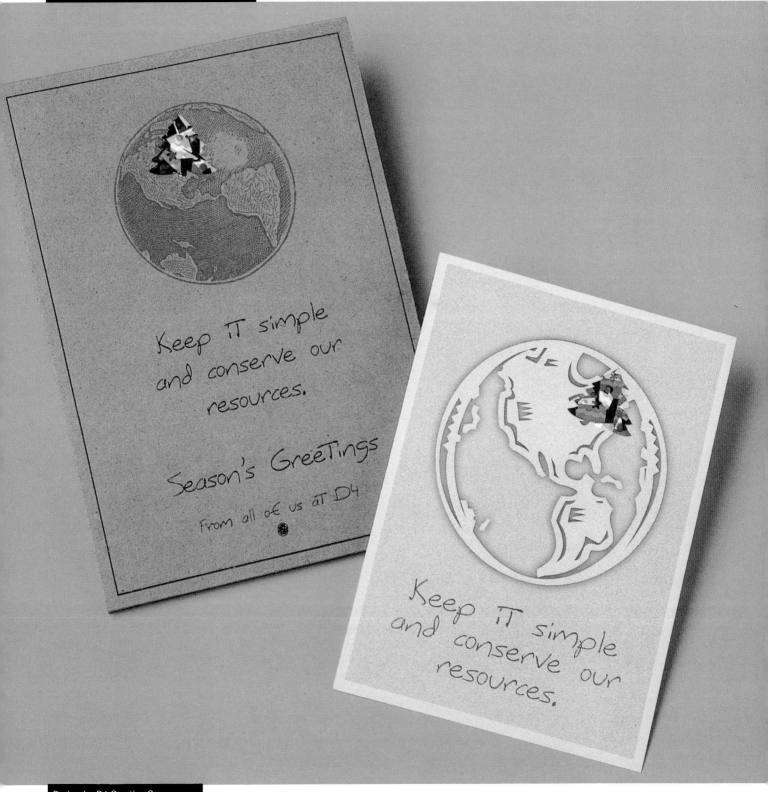

Design by D4 Creative Group
All Design: Wicky W. Lee

In the Public Interest

Reshaping the Business
of Behavioral Health

March 31- April 2, 1996
Atlanta, Georgia

Design by HC Design
Art Director: Chuck Sundin
Designer/Illustrator: Steve Trapero

This brochure and postcard were sent to mental-health professionals; the weight of the conference is conveyed by the nonspecific gender of the logo, the two earthy PMS colors used in printing, and the substantial Simpson Quest paper the pieces were printed on.

You Are Invited

to attend the 1996 Annual Training Conference

Early Registration Rates

National Council Members: $350

Nonmembers: $450

Special rates at the

Atlanta Marriott Marquis

Single: $129

In the Public Interest

Reshaping the Business
of Behavioral Health

Register Before December 31 and save $50!

Training senior management and
leadership in the operational
components of providing high quality
behavioral healthcare services, across
traditional boundaries, and with new
and varied partners.

1996 Annual
Training Conference

March 31- April 2, 1996

Atlanta Marriott Marquis
Atlanta, Georgia

National Community Mental Healthcare Council • 1996 Training Conference

M O U N T
ST. MARY'S
COLLEGE

ANNIVERSARY

70TH

A SPECIAL WEEKEND of events . . .
to celebrate the achievements of the past
70 years, to recognize the excellence of
the present, and to acknowledge the
potential of the future of
Mount St. Mary's College.

1 9 2 5 - 1 9 9 5

Join us

You, your spouse, your family and friends are
cordially invited to celebrate these momentous
MSMC milestones:

• the reunions of the baccalaureate classes of 1950,
1955, 1960, 1965, 1970, 1975, 1980, 1985
• the 70th anniversary of the founding of the College
• the presentation of the Outstanding Alumna/us
Awards to:

Paul Salamunovich '61
Dorothy Caruso-Herman '76
Gina Poli Hsiung '80

• the rededication of the renovated Coe Library
• and a special capital campaign announcement.

Mount
ST. MARY'S
COLLEGE

FRIDAY, OCTOBER 6 • SATURDAY, OCTOBER 7 • SUNDAY, OCTOBER 8

Design by Clark Design
Art Director: Annemarie Clark
Designer: Craig Stout

RSVP

REGISTRATION CARD

Please detach and return to Alumnae Office, 12001 Chalon Rd., Los Angeles, CA 90049.
Please make checks payable to Mount St. Mary's College.
Sisters of St. Joseph of Carondelet are guests of the Alumnae Association.

FRIDAY, OCTOBER 6, 1995

❑ Enroll me for Back to School! My class choice(s) is/are:

SATURDAY, OCTOBER 7,

❑ Enclosed is my check for $_____ ($30 each
to attend the Women Reading Women Hsiung Seminar,
Deadline: September 30.

❑ Session I Workshop:
❑ Session II Workshop:

❑ Enclosed is my check for $_____ ($40 each)
to attend the Reunion Reception only.

❑ Enclosed is my check for $_____ ($30 each)
to attend the Reunion Social and Dinner with the Class of

❑ I will be staying at the Brentwood Holiday Inn and will need shuttle
service to Doheny.

SUNDAY, OCTOBER 8, 1995

❑ Please make reservations for _____ persons for Founders Day with the Class
of _____. (Enclose name(s) of guest(s).)

❑ Please reserve _____ places on the tour of the Library scheduled for:
❑ 10:30 am ❑ 2:00 pm ❑ 3:30 pm

❑ Please forward information on wheelchair and disabled access for
campus facilities.

Name: _____ Class Year: _____
Day phone: _____ Evening phone: _____
Name(s) of guest(s): _____

Do you have—among your souvenirs of the Mount—any snapshots or photos you would
like to share with fellow classmates? If so please send them (in the negative) with your
reservation. We will have some mounted and ready for everyone to enjoy.

Design: Clark Design, San Francisco

M O U N T
ST. MARY'S
COLLEGE

JOIN US FOR
FOUNDERS
DAY
AND CLASS REUNIONS

'95

OCTOBER 6 · 8
1 9 9 5

This job wasn't just low-budget, it was pro-bono; the
designer's challenge was to get all the necessary
information onto a single printed piece. Using
different type styles and two PMS colors, the design
is inviting, readable, and inexpensive to produce.

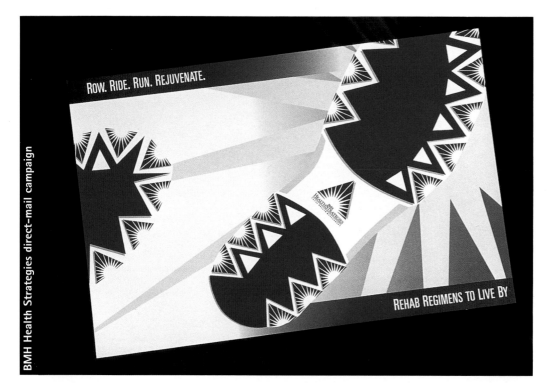

ROW. RIDE. RUN. REJUVENATE.

REHAB REGIMENS TO LIVE BY

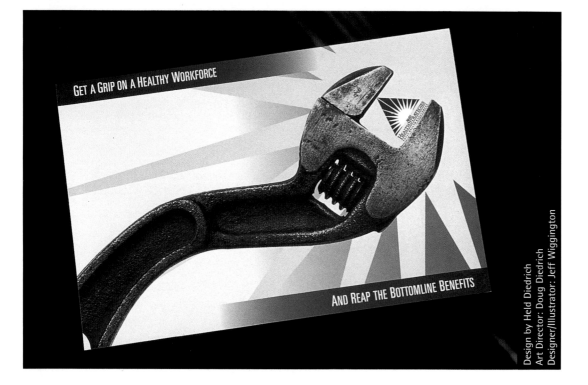

GET A GRIP ON A HEALTHY WORKFORCE

AND REAP THE BOTTOMLINE BENEFITS

Design by Held Diedrich
Art Director: Doug Diedrich
Designer/Illustrator: Jeff Wiggington

To create an interesting and identifiable direct-mail campaign

on a shoestring, the designers used stock CD images and

processed with Adobe Illustrator and Photoshop. The results

were printed in a single shade of indigo.

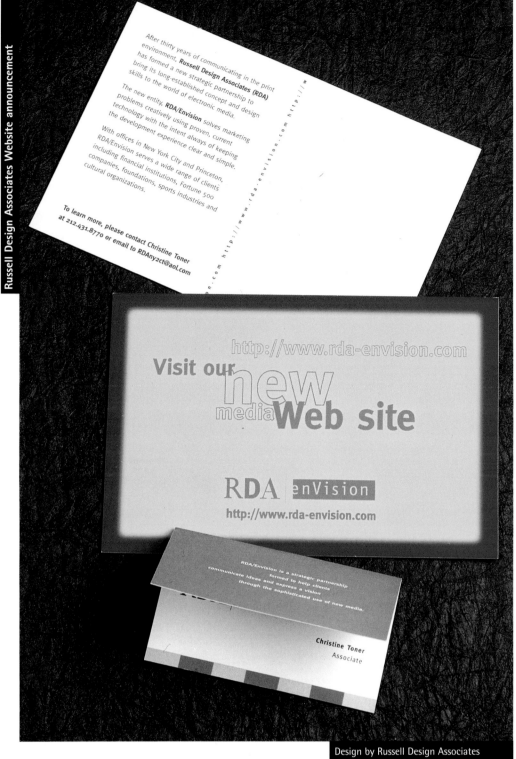

After thirty years of communicating in the print environment, **Russell Design Associates (RDA)** has formed a new strategic partnership to bring its long-established concept and design skills to the world of electronic media.

The new entity, **RDA/Envision** solves marketing problems creatively using proven, current technology with the intent always of keeping the development experience clear and simple.

With offices in New York City and Princeton, RDA/Envision serves a wide range of clients including financial institutions, Fortune 500 companies, foundations, sports industries and cultural organizations.

To learn more, please contact Christine Toner at 212.431.8770 or email to RDAny2ct@aol.com

http://www.rda-envision.com

Visit our new media **Web site**

RDA enVision

http://www.rda-envision.com

RDA/Envision is a strategic partnership formed to help clients communicate ideas and express a vision through the sophisticated use of new media.

Christine Toner
Associate

Design by Russell Design Associates
Art Director: Anthony Russell
Designer: Sofia F. de Ana Portela

By choosing the right two colors,

the designers created a postcard

that is not only well within budget

but conveys the excitement of the

firm's new Website.

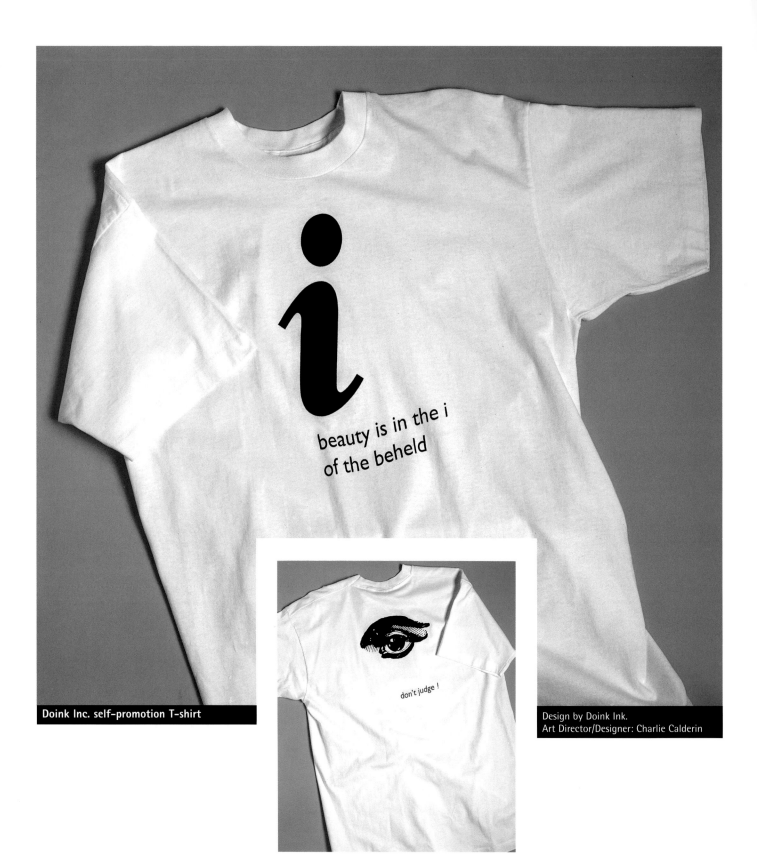

Doink Inc. self-promotion T-shirt

beauty is in the i
of the beheld

don't judge !

Design by Doink Ink.
Art Director/Designer: Charlie Calderin

The beauty of this T-shirt is in the resourcefulness of its design. A found image, large-scale type, and the designer's own feeling about individuality were printed in a single color without any loss of impact.

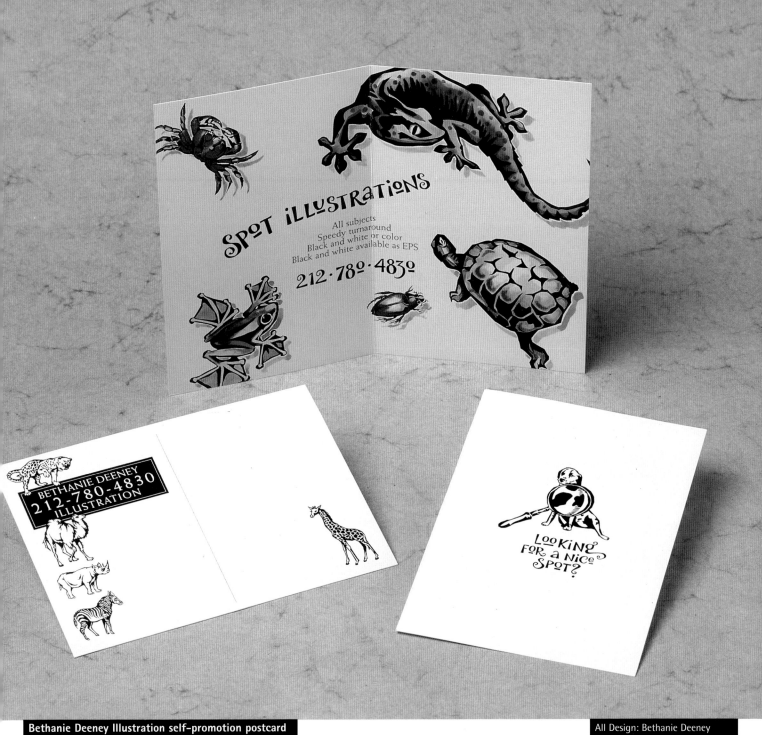

Bethanie Deeney Illustration self-promotion postcard

All Design: Bethanie Deeney

To show her proficiency with spot illustrations, this artist created a series of black-and-white illustrations in Adobe Illustrator. She hand-colored the images on the one-fold card using Luma dyes.

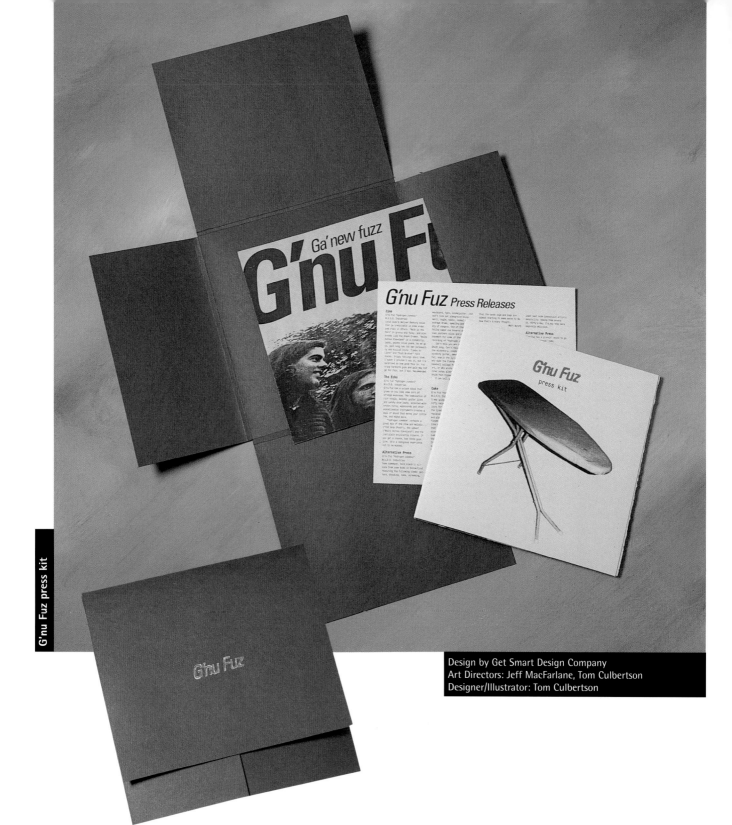

Design by Get Smart Design Company
Art Directors: Jeff MacFarlane, Tom Culbertson
Designer/Illustrator: Tom Culbertson

With a total run of about 50 pieces, the answer to
the small-budget needs of this dynamic press kit was
hand assembly. Laser-printed, the piece was trimmed,
folded, stamped, and assembled by hand.

To distinguish between the three levels of donation for UNC's College of Architecture Library, a single color of ink was printed onto three different shades of Classic Crest paper.

Design by Shook Design Group, Inc.
Designers: Ginger Riley, Graham Schulken

UNC-Charlotte College of Architecture solicitation for donations

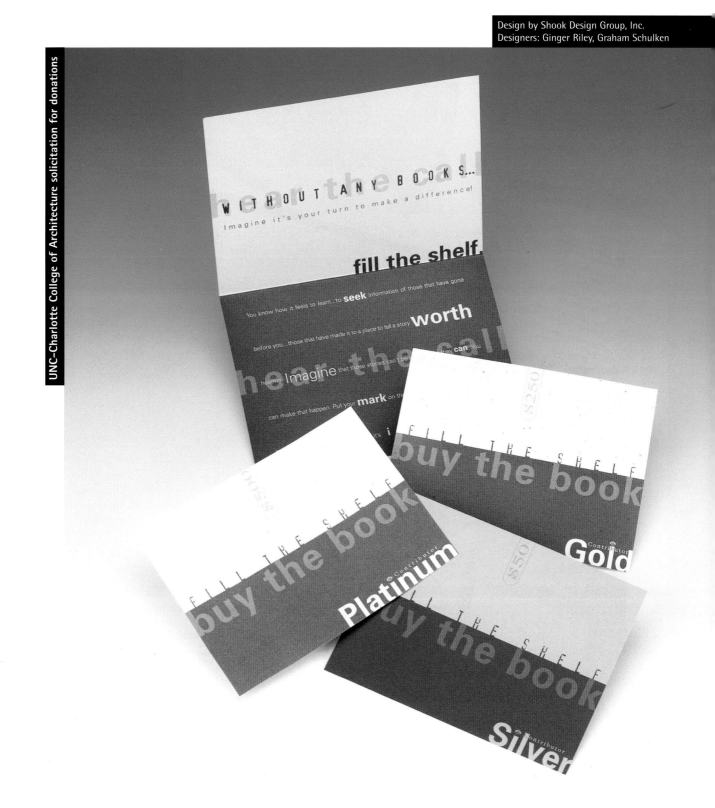

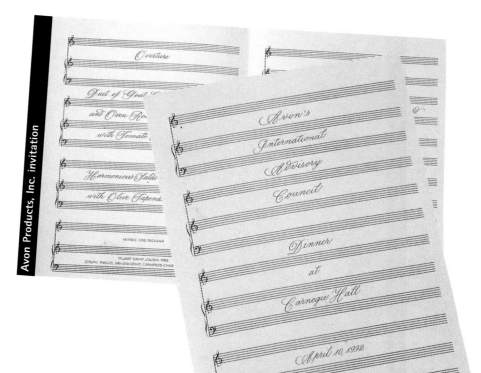

This keepsake menu for a gala dinner at Carnegie Hall uses blank music sheets to list the well-orchestrated menu. To add a touch of old-world elegance, the piece includes hand-lettered copperplate script.

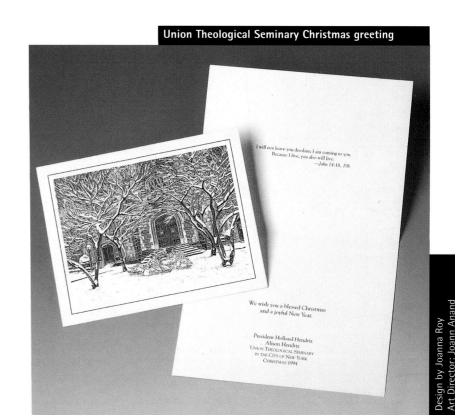

The illustrator made black-and-white drawings from a series of photographs taken at the seminary after a snowfall. The quiet, reflective image is underscored by the reserved typeface. Printing in a single color was the obvious choice, both in terms of cost and aesthetics.

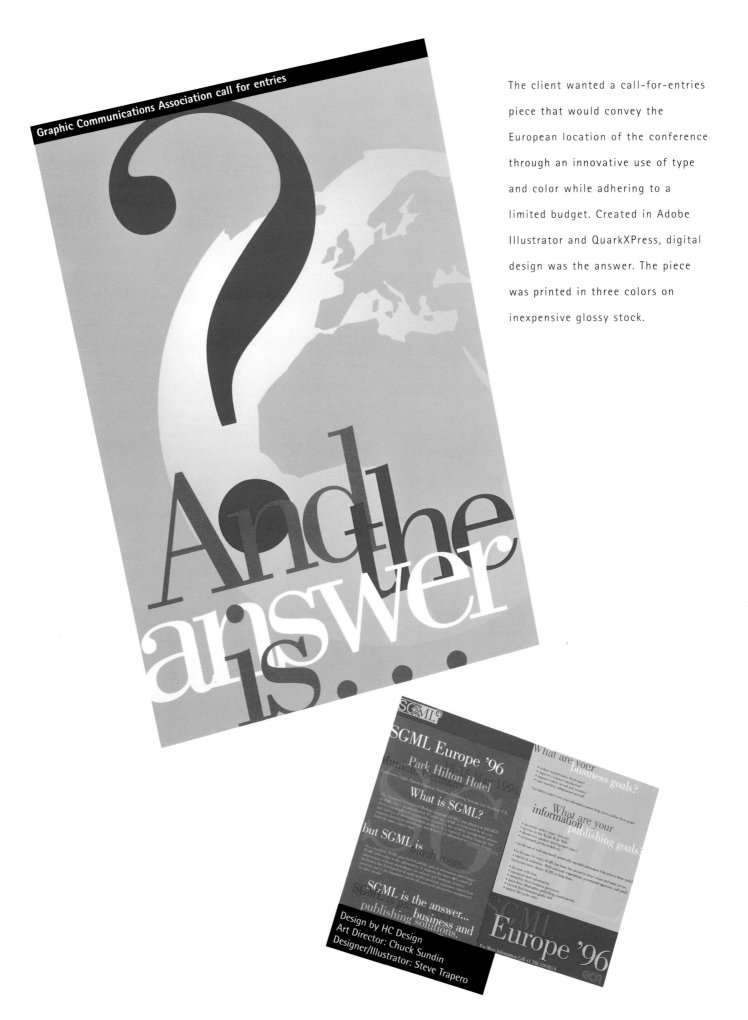

The client wanted a call-for-entries piece that would convey the European location of the conference through an innovative use of type and color while adhering to a limited budget. Created in Adobe Illustrator and QuarkXPress, digital design was the answer. The piece was printed in three colors on inexpensive glossy stock.

It was important that these direct-mail gifts for corporate clients have a rich feel, while being affordable to produce. The solution lay in the two-color printing. Metallic copper and deep evergreen inks were used to give each piece a natural, approachable richness.

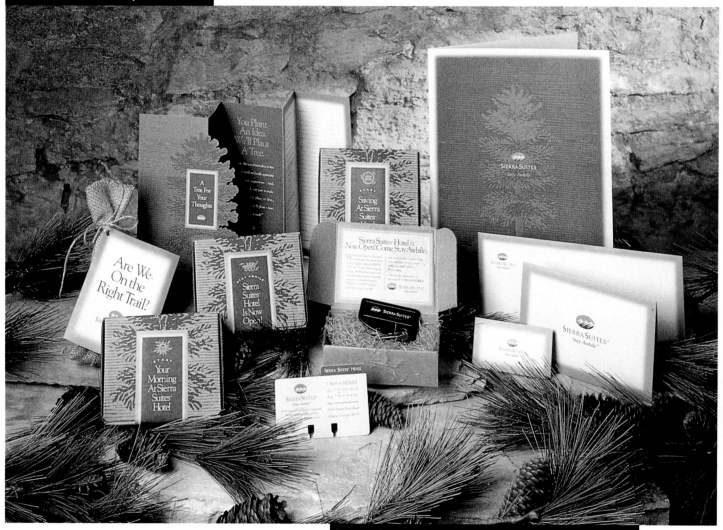

Design by Greteman Group
Art Directors/Designers/Illustrators: Sonia Greteman, James Strange, Craig Tomson

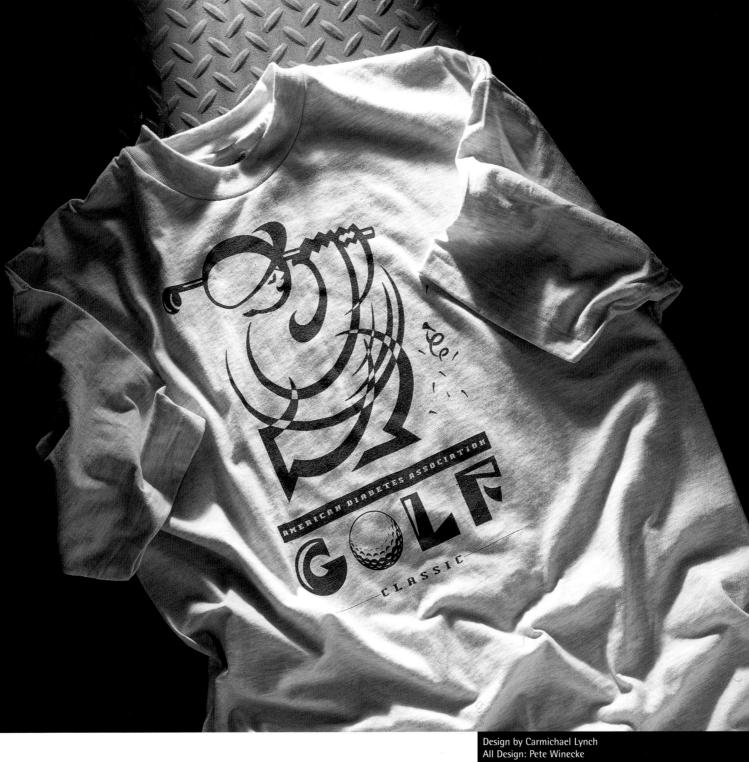

Design by Carmichael Lynch
All Design: Pete Winecke

This swinging T-shirt features a logo in which long, curving lines create a satisfied-looking golfer—an active visual grounded by a horizontal line and rather whimsical but substantial lettering. A single color of green is a totally appropriate, cost-cutting design choice.

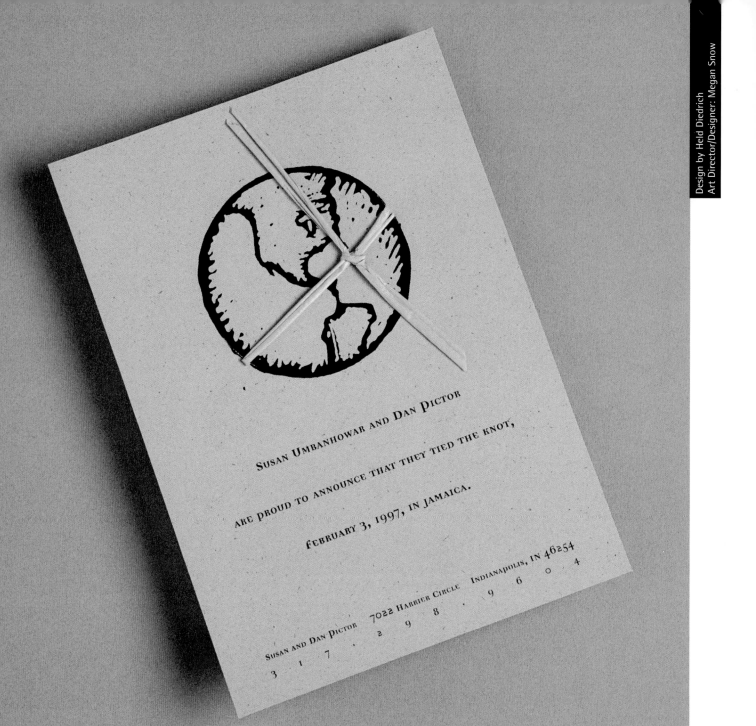

Design by Held Diedrich
Art Director/Designer: Megan Snow

SUSAN UMBANHOWAR AND DAN PICTOR

ARE PROUD TO ANNOUNCE THAT THEY TIED THE KNOT,

FEBRUARY 3, 1997, IN JAMAICA.

SUSAN AND DAN PICTOR 7022 HARRIER CIRCLE INDIANAPOLIS, IN 46254
3 1 7 2 9 8 9 6 0 4

Susan and Dan Pictor wedding announcement

Tying the knot becomes the aesthetic thread that brings this one-color wedding announcement together. The woodcut-style globe indicates that the wedding ceremony on a Jamaican beach brought together a bride and groom from different parts of the world.

By using a Macintosh to create this letterhead design, plus interesting papers (including a translucent business card), the designer was able to imply strength, stability, and fine quality—all while using a single color of ink.

Bohl Metall In Form letterhead

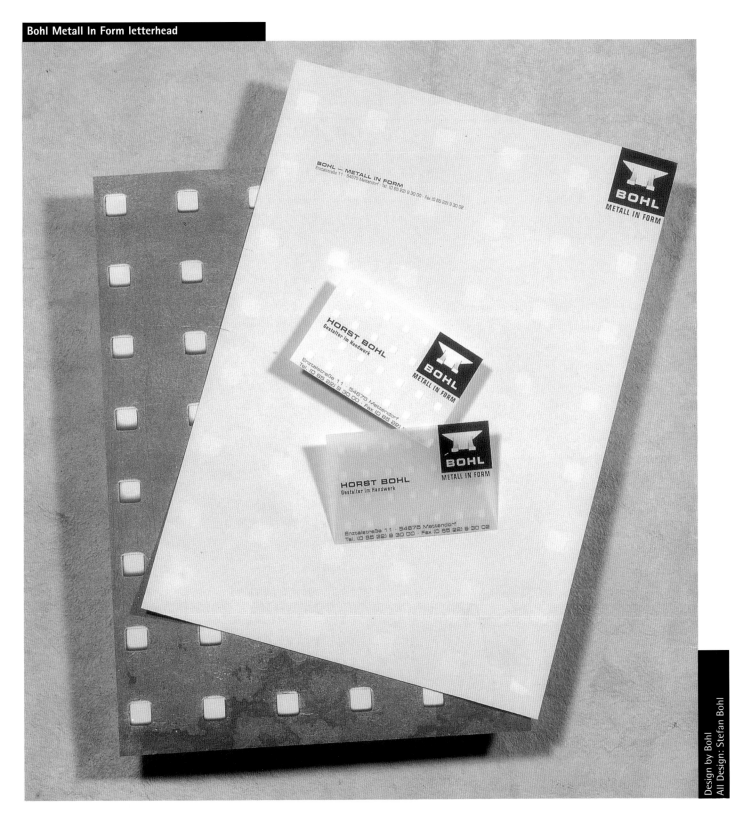

Able Design, Inc. 10
54 West 21st Street, #705
New York, NY 10010

After Hours Creative 21
1201 East Jefferson 8100
Phoenix, AZ 85034

American Art Studio 88
124 West 24th Street, #2A
New York, NY 10011

Austin Design 73
7 Columbia Terrace
Brookline, MA 02146

Bakagai Design 33
221 West Eugenie, 1F
Chicago, IL 60614

Base Art Company 61
3047 Fair Avenue
Columbus, OH 43209

Becker Design 41, 48
225 East St. Paul Avenue, Suite 300
Milwaukee, WI 53202

Bohl 93
Karl Marxstrasse 80
D-54290 Trier
Germany

Carmichael Lynch 91
800 Hennepin
Minneapolis, MN 55403

Art Chantry 24
P. O. Box 4069
Seattle, WA 98104

Charles Carpenter Illustration and Design 46
2724 South Armacost West
Los Angeles, CA 90064

Clark Design 77
444 Spear Street, Suite 210
San Francisco, CA 94105

Copeland Hirthler Design and Communications 27
40 Inwood Circle
Atlanta, GA 30309

D4 Creative Group 75
4100 Main Street, Suite 210
Philadelphia, PA 19127-1623

Bethanie Deeney 81
31 E 31st Street, #12C
New York, NY 10016

Design Factory 39
59 Merrion Square
Dublin 2
Ireland

Design Horizons International 20, 37
520 West Erie, Suite 230
Chicago, IL 60610

Dogstar 71
626 54th Street South
Birmingham, AL 35212

Doink, Inc. 80
P. O. Box 145249
Coral Gables, FL 33114

Dragon's Teeth Design 54
419 College Avenue
Greensburg, PA 15601

elDesign 26
P. O. Box 341
Trenton, MI 48183

Elena Design 13
3024 Old Orchard Lane
Bedford, TX 76021

Entheos Design 65
1422 24th Street, #4
Kenosha, WI 53140

Eric Kass Design 22
11523 Cherry Blossom Drive
Fishers, IN 46038

Franz and Company Inc. 62
3309-G Hampton Point Drive
Silver Spring, MD 20904

Get Smart Design Company 20, 82
899 Jackson Street
Dubuque, IA 52001

Graif Design 9
985 South Firefly Road
Nixa, MO 65714

Greteman Group 21, 90
142 North Mosley
Wichitia, KS 67202

HC Design 76, 89
3309-G Hampton Point Drive
Silver Spring, Md 20904

Held Diedrich 78, 92
703 East 30th Street, Suite 16
Indianapolis, IN 46205

Hornall Anderson Design Works 43, 53
1008 Western Avenue
Suite 600
Seattle, WA 98104

Icehouse Design 12, 72
135 West Elm Street
New Haven, CT 06515

Inland Group, Inc. 31
222A North Main
Edwardsville, IL 62025

Insight Design Communications 35
322 South Mosley
Wichita, KS 67202

J. Graham Hanson Design 66, 87
307 East 89th Street, #6G
New York, NY 10128

Jeff Labbé Design Co. 40
218 Princeton Avenue
Claremont, CA 91711

Julia Tam Design 52, 61
2216 Via La Brea
Palos Verdes, CA 90274

Larry Burke-Weiner Design 6
832 South Woodlawn Avenue
Bloomington, IN 47401

Lead Dog Communications 51
33 Beverly Road
Kensington, CA 94707

Lightner Design 32
9730 SW Cynthia Street
Beaverton, OR 97008

Louise Fili, Ltd. 49
71 5th Avenue
New York, NY 10003

Love Packaging Group 11, 38, 85
410 East 37th Street North
Plant 2, Graphics Dept.
Wichita, KS 67219

Manley Design 14, 25, 69
255 Budlong Road
Cranston, RI 02920

Barbara Maslen 18
55 Bayview Avenue
Sag Harbor, NY 11963

McGaughy Design 60
3706-A Steppescourt
Falls Church, VA 22041

Melissa Passehl Design 15
1275 Lincoln Avenue, Suite 7
San Jose, CA 95125

Metal Studio, Inc. 7
1210 West Clay, Suite 13
Houston, TX 77019

Mike Salisbury Communications, Inc. 29
2200 Amapola Court, Suite 202
Torrance, CA 90501

Mires Design 44, 66
2345 Kettner Boulevard
San Diego, CA 92101

Misha Design Studio 86
1638 Commonwealth Avenue, #24
Boston, MA 02135

Monnens-Addis Design 57
2515 Ninth Street
Berkeley, CA 94710

Paper Shrine 58
604 France Street
Baton Rouge, LA 70802

Carmine Petretto 56
Bear Creek Corp.
2518 South Pacific Highway
Medford, OR 97501

Rick Eiber Design (RED) 64
31014 SE 58th Street
Preston, WA 98050

Joanna Roy 88
549 West 123 Street
New York, NY 10027

Russell Design Associates 79
584 Broadway
New York, NY 10012

Sagmeister, Inc. 16
222 West 14th Street, #15A
New York, NY 10011

George Samerjan 84
201 Apple Tree Lane
Brewster, NY 10509

Ann Samul 54
11 Pacific Street
New London, CT 06320

Sandy Gin Design 28
329 High Street
Palo Alto, CA 94301

Sayles Graphic Design 19, 23, 24
308 Eighth Street
Des Moines, IA 50309

Schudlich Design & Illustration 55
1064 Milwaukee
Denver, CO 80206

Sheaff Dorman Purins 47
460 Hillside Avenue
Needham, MA 02194

Shields Design 63
415 East Olive Avenue
Fresno, CA 93728

Shook Design Group, Inc. 36, 83
2000 South Boulevard, Suite 510
Charlotte, NC 28203

Tracy Griffin Sleeter 17
RR 22, Box 6
Bloomington, IL 61701

Standard Deluxe, Inc. 85
171 Doolittle Lane
Waverly, AL 36879

Paul Stoddard 34
524 Main Street
Stoneham, MA 02180

Stoltze Design 25, 30
49 Melcher Street, Fourth Floor
Boston, MA 02210

Stowe Design 67
125 University Avenue, Suite 220
Palo Alto, CA 94301

Teikna 26, 42, 59
366 Adelaide Street East, Suite 541
Toronto, ON M5A 3X9
Canada

The Weller Institute 50
P. O. 518
Oakley, UT 84055

This Gunn for Hire 36
1428 Caminito Septimo
Cardiff, CA 92007

Tim Noonan Design 8
410 NW 18th Avenue
Portland, OR 97209

Toni Schowalter Design 34, 74
1133 Broadway, 1610
New York, NY

Voss Design 70
Witteringstrasse 33
D-95130 Essen
Germany

X Design Company 47, 68
2525 West Main Street, Suite 201
Littleton, CO 80120

Zauhar Design 45
510 1st Avenue N #405
Minneapolis, MN 55403